This Bountiful Place

Art
About Agriculture
The Permanent Collection

A RETROSPECTIVE EXHIBITION

This Bountiful Place

Art *About* **Agriculture** *The Permanent Collection*

Shelley Curtis, Editor

OREGON STATE UNIVERSITY ❧ COLLEGE OF AGRICULTURAL SCIENCES
OREGON HISTORICAL SOCIETY ❧ PORTLAND, OREGON

This catalog is made possible by a generous gift from Brenda Hood of Corvallis in memory of her late husband, John Gordon Hood, who was a part of the Oregon State University Extension Service from 1945 until his death in 1966. Gordon first served until 1951 in Astoria as Clatsop County Extension agent and, later, in statewide Extension leadership posts. Brenda has lived in Corvallis since 1951 and, after Gordon's death, was assistant to several presidents of Oregon State University. She retired in 1975. Brenda has long been a patron of the arts and attended many opening receptions for Art About Agriculture. It was her appreciation for this innovative program that inspired her to recognize Gordon with a gift that would enable this published presentation of the permanent collection.

—*Gwil Evans*

Retrospective Exhibition, Oregon Historical Society, Portland, Oregon, May 19–September 17, 2006.
Cover art: *Ripening Tomatoes* by Kathryn Honey.
Back cover art: *Spring Series #3* by Nelson Sandgren.
Book and cover design by Cheryl McLean.
Art photographed by Peter Krupp Photography, Corvallis; PhotoBach Studio, Corvallis; Bob Ross Photography, Albany; and Shadow Smith Photographers, Corvallis.
Printed by Lynx Group, Salem, Oregon.

Published in association with the Oregon Historical Society Press, 1200 SW Park Avenue, Portland, Oregon 97205.

ISBN-13: 978-0-87595-303-8; ISBN-10: 0-87595-303-4

Library of Congress Cataloging-in-Publication Data

This bountiful place: Art About Agriculture: the permanent collection / Shelley Curtis, editor.
 p. cm.
 Exhibition catalog.
 Includes bibliographical references and index.
 ISBN-13: 978-0-87595-303-8 (alk. paper)
 ISBN-10: 0-87595-303-4 (alk. paper)
 1. Agriculture in art—Exhibitions. 2. Art, American—Northwest, Pacific—20th century—Exhibitions. 3. Art, American—Northwest, Pacific—21st century—Exhibitions. 4. Art—Oregon—Corvallis—Exhibitions. 5. Oregon State University. Art About Agriculture—Art collections—Exhibitions. I. Curtis, Shelley.
 N8217.A49T55 2006
 758'.7—dc22
 2006013133

This book is printed on acid-free paper.

Contents

Foreword

By Shelley Curtis

This exhibition celebrates the Art About Agriculture Permanent Collection of contemporary fine art and nearly a quarter century of acquiring art for this collection by the Oregon State University College of Agricultural Sciences. The College accessions art in partnership with the OSU Foundation and many generous patrons and artists who participate in advancing the Art About Agriculture program. This is the second exhibit of the entire permanent collection since March 1983, when eleven newly acquired artworks were displayed as part of the program's first annual, inaugural touring exhibition.

Imagining 'place' is an intrinsic part of human nature that we all share. The College of Agricultural Sciences supports this essence in Art About Agriculture, nurturing collaboration among research scientists, visual artists in the Northwest, and alumni and friends of the College. With this diversified thinking about natural resources, through the sciences, the arts, and citizenship, the program forms our sensibilities with works of art that reflect agrarian heritages and the significance of agriculture today. Thereby the College creates and educates through tangible and intellectual ranges of its mission.

The Art About Agriculture Permanent Collection is a contemporary thematic art collection relating to agriculture and natural resources. Given that each artwork was produced and accessioned into the collection since 1980, aesthetics from both Modernist and Postmodernist art periods intertwine throughout. For example, in *Filberts*, oil on canvas (reproduced in color on page 21), Sally Haley (b. 1908) exercises classic Modernist ideals using basic color, line, the illusion of light, and shape as universal language. Haley

Filberts
Sally Haley

carefully constructes these elements to create the realism of a woven basket generously full of unshelled hazelnuts, each accurately modeled with textures and tones. She minimally suggests an environment far removed from garden or orchard with an arrangement of broad ochre squares more closely resembling a courtyard lanai.

Haley's painting is in contrast to many mixed media pieces in the permanent collection. Some of these are simply combinations of two or more traditional art media. Others are elaborate assemblages of natural and human made fragments: feathers, computer chips, and bits of plastic and metal that are glued, sewn, and tied together into multilayered compositions. Janice Staver's (b. 1939) *Boys, My Money's All Gone* is a paper collage that combines

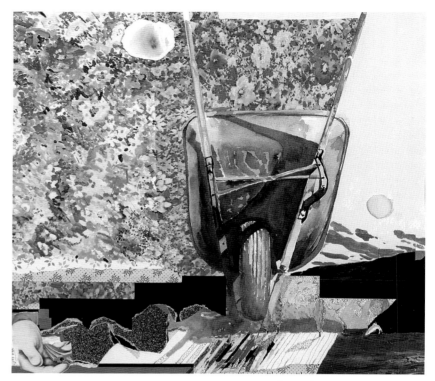

Boys, My Money's All Gone
Janice Staver

drawings, pieces of wallpaper, photographs, and watercolor (see also page 181). Staver's subject, a well-worn wheelbarrow propped against a wall, is surrounded by random details that enrich the narrative content. A fish breaking the surface of its pond, tiny trees casting shadows on pavement, a floral pattern of mixed clarity and obscurity, layers of cut and torn edges, and searing light from two suns swirl around the upright handcart. Visually action-packed as it is, Staver's collage captivates attention while resonating the title's immediacy and consequence throughout.

Pricilla Hanson's (b. 1945) aerial view, *Outside Sheridan*, an acrylic, paper tape, pencil, and transfer on board (see also page 33), appropriates forced perspectives of the present day. Composed mostly of rectangles and monochromes, Hanson's painting invites complex considerations of human interaction with the land. Being aloft inspires her observation of the earth as a large-scale agricultural design of several grass farms in the

Willamette Valley. These fields in production are bordered at the top by a blue-black stretch of river water and delicately buttressed at the lower edge by subdivision plans for a sinuous street and measured grid of housing lots. Hanson says, "I am attracted to the marks and symbols we use to explain the world, in the methodologies of mapping and documenting. I use these marks as an expression of our attempts to order, to understand, to give meaning to natural phenomena."

Art About Agriculture is a treasure that distinguishes Oregon State University with an identity unique among America's land-grant institutions. However, the University has no museum, giving the permanent collection yet another notable postmodern trait, its transitory nature. The art is continuously on loan across campus and elsewhere throughout Oregon. The College of Agricultural Sciences is grateful to the Oregon Historical Society in Portland, Oregon, for its partnership in organizing this exhibition, and for the chance to survey the art in a single space for a period of time.

Nearly 200 artworks, including drawings, mixed media, paintings, prints, photographs, sculptures, textiles, and watercolors, create a spectacular place as the subject of this exhibition and companion catalog. In realization of a dream to acquaint people with agriculture of the majestic Northwest and beyond, the OSU College of Agricultural Sciences welcomes you to its presentation, *This Bountiful Place: Art About Agriculture—The Permanent Collection*.

Outside Sheridan
Priscilla Hanson

Acknowledgments

Support from the Oregon State University College of Agricultural Sciences has made Art About Agriculture possible since the program was initiated in 1983. Through this unique program, the College has created a lasting treasure, distinguishing the University with an art collection among the most significant in the Northwest. The Art About Agriculture annual exhibit program will allow this collection to continue to grow.

The College acknowledges Brenda Hood for sponsoring this retrospective exhibition of the Art About Agriculture Permanent Collection and this catalog in memory of her late husband, John Gordon Hood. John Pierce, executive director of the Oregon Historical Society, joins Brenda Hood in a partnership with the College for presenting this exhibition. Under John Pierce's directorship, the College benefited immeasurably by coordinating with Marsha Matthews, director of artifact collections and exhibits; Franc Gigante, exhibit production manager; and Cara Unger, education director, who enlisted Pat Courtney Gold and Bill Robbins as speakers for public talks related to the exhibition. The College is grateful to the Oregon Historical Society Press, director Marianne Keddington-Lang, and production editor Eliza Jones for supporting the publication of this catalog.

Leadership and patronage from many individuals is a privilege that the College is grateful to share, especially from their donations to the College, specifically for Art About Agriculture artists' awards. The catalog's Provenance section includes a comprehensive list of purchase award sponsorship for works of art accessioned into the permanent collection. The College recognizes several patrons for advancing the program by establishing awards endowments.

Birgitta and Frank Lamb of Morrow County, Oregon, seeded the program with major gifts from 1983 to 1986, which established a general Art About Agriculture endowment. Then in 1987, the Lambs established the Paul Lamb and Reese Lamb Art About Agriculture Award endowment through their Lamb Foundation, known at that time as the OCRI Foundation.

A gift from Gayle Strome of Lane County established an endowment in 1986 for the Carey and Glen S. Strome Agricultural Art Memorial Award to honor the memory of her mother- and father-in-law. This gift is also for promoting artists representing the Oregon seed industry.

Upon her retirement from the Oregon State University Foundation in 2001, Betty Brose established an endowment for the Betty Brose Art About Agriculture Award. It was funded by gifts from many people to recognize Betty for her dedicated OSU tenure as a College fundraiser, as well as a gift of matching funds from the E. R. Jackman Board of Directors to honor Betty.

The program received a major gift, also in 2001, from the Roy D. Nielsen family to establish the Roy D. Nielsen Art About Agriculture Award. Annual gifts from Gwil Evans and William Cook continue to support this award. The Nielsen family initiated this award in memory of Roy, who died in 1958 while a student at Oregon State University.

Annual gifts for artists' awards are yet another resource for awards granted to artists. Annual award sponsors include: Roy and Jane Arnold; Cande and Gene Buccola; *Capital Press* editors, the late Dewey Rand, Mike Forrester, Elaine Shein, and general manager Mike O'Brien; Jim and Stella Coakley; the Curtis family; Missy and Thayne Dutson; Elanco; Danielle Fournier; Larry and Sherry Kaseberg; L. J. "Kelvin" Koong; Land O'Lakes Foundation; Monsanto; C. L. Neuman Company; Oatmeal Baking Company; Oregon Arts Commission director Christine D'Arcy; OSU College of Liberal Arts dean Kay Schaffer and dean emeritus Bill Wilkins; OSU Graduate School dean emeritus Tom Maresh and his wife, Carloyn Maresh; OSU former presidents and their wives, John and Shirley Byrne, Paul and Les Risser, Tim and Karen White, and current OSU president Ed Ray and his wife, Beth Ray; OSU vice provost for research emeritus George Keller and his wife, Suzanne Keller; Ron Theis; and Conrad J. and Deanie Weiser.

By supporting Art About Agriculture, the College fosters many valuable relationships within the University community and throughout the Northwest for displaying art from its permanent collection. Artworks from the permanent collection are displayed across the OSU main campus and in other locations throughout Oregon. Host galleries for the annual touring exhibitions are listed in Appendix II.

The OSU LaSells Stewart Center has hosted the annual inaugural Art About Agriculture exhibitions and artists' receptions and awards presentations each year, with the exception of 2002. The Giustina Gallery in LaSells Stewart Center provides more than 200 linear feet of display space. Until 1999, Art About Agriculture exhibits in the Giustina Gallery were designed by the OSU Department of Art, thereby indirectly affording the College a helpful partnership with the Department of Art. The OSU Memorial Union directors hosted the Art About Agriculture 2002 inaugural exhibition in the Concourse Gallery and the artists' reception and awards presentation in the Memorial Union Lounge.

The College thanks catalog authors Lois Allan and Gwil Evans for their contributions to this volume. Lois Allan researched the collection and interviewed several artists and professors before authoring her illuminating essay, "Art About Agriculture." In his essay, "History: Art About Agriculture," Gwil Evans enlightens us by sharing his firsthand knowledge of the program's beginnings. The College is grateful to Cheryl McLean for her inspiring catalog design in addition to her marketing efforts for the publication. Very special thanks to Nancy Hagood, Marsha Matthews, Aaron Poor, and Carol Savonen for reading drafts of this manuscript, and to Robert Joki for reviewing Lois Allan's essay.

Artists whose work is part of Art About Agriculture express a wealth of ideas. The College is always grateful for their profound efforts. Represented artists are listed in the Provenance section by name, current residence, birth year and place, and current gallery association; title, medium, size, and production year of their art; and the award and sponsorship through which the piece was accessioned into the permanent collection. The College is grateful to all the artists who granted permission to reproduce their art for this catalog and to family members and spouses who granted copyright permissions for artists no longer living.

Jurors serving as unpaid volunteers for the program's annual competitions provide vital and commendable service. Each is mentioned in Appendix I by name. Their selections have shaped the quality, breadth, and consequence of the Art About Agriculture Permanent Collection. It is this art you will see on the pages of this catalog and in the retrospective exhibition.

— *Shelley Curtis, Directing Curator,*
Art About Agriculture

History
Art About Agriculture

By Gwil Evans

elieved to be the first and largest university-based collection of fine art that is inspired by agriculture, food, and natural resources, the Oregon State University College of Agricultural Sciences Art About Agriculture program has its origins in addressing a need to bridge urban and rural Oregon.

Once the United States' population began its inexorable move from rural communities to urban centers, those who produced food and fiber worried that urban dwellers would not continue to appreciate where their food came from or all that it took to produce it. By the 1980s, although many people in Oregon and across the nation still earned their living even in city-based jobs that relied on agricultural production, processing, finance, and the like, there were fewer farmers on ever-larger farms. When they got together at meetings of commodity groups, the Farm Bureau, or other organizations, Oregonians engaged in agriculture sometimes spoke their hope that urban Oregonians would understand and appreciate their state's agriculture and natural resource industries. They were not without action to address this concern. Organizations or businesses—including the Oregon Agri-Business Council, the Farm Bureau, the then-E.R. Jackman Foundation, the weekly *Capital Press*, and even *The Oregonian*—undertook to inform. Then early in his tenure as dean of what was, at the time, the School of Agriculture at Oregon State, Ernest J. Briskey heard the same message from members of his School's Oregon Agricultural Research and Education Policy Advisory Board. He began to act.

Art About Agriculture creates connection between rural and urban Oregon through art.

The first Art About Agriculture exhibit in 1983 was held in the OSU LaSells Stewart Center Giustina Gallery.

When he consulted with two OSU faculty members, Ken Kingsley and me, in the Department of Agricultural Communications, Briskey was intrigued by an idea we had tested earlier with leadership of the Portland Art Museum. Seeking a "common denominator" that would have inherent value and meaning for any Oregonian, regardless of where she or he lived, we envisioned a fine arts–based program that would encourage Pacific Northwest artists to seek creative stimulation from whatever the artist perceived as related to agriculture, food, or natural resources. The program, Kingsley and I argued, would annually draw together works that were products of such artistic stimulation and would present those works in shows throughout the state: shows that would attract urban and rural people alike. Another component of the annual program cycle would be an opening and recognition event for artists whose works had been selected to be part of the show. Some pieces would be purchased and, over time, would become part of a dynamic, growing permanent collection of artworks owned by what was then the School of Agriculture. The idea resonated not only with the dean, but with Joanna Wilson, then a development officer with the OSU Foundation. Wilson and Briskey believed it was an idea that might be well received by some Oregonians associated with agriculture and natural resources who likewise could see the possibilities. At the dean's request in July 1982, I prepared a short prospectus that presented key concepts for what these planners chose to call "Art About Agriculture" (having rejected "Art in Agriculture"). Armed with this prospectus, Briskey and Wilson soon met with Frank and Birgitta Lamb. The Lambs were widely known eastern Oregon agricultural producers and processors who embraced leading-edge practices and technology in their farming operations and who also were engaged in cultural activities. Soon, the Lambs arranged a grant from their OCRI Foundation to establish Art About Agriculture. The first annual competition and resulting exhibit was to take place at the LaSells Stewart Center in conjunction with an event called "Agricultural Conference Days." That was 1983.

For the new program, Briskey enlisted the leadership of Tom Allen, a professor of botany and plant pathology, himself a watercolorist whose works are widely known in the Pacific Northwest. Bestowed with the title "artist in residence" for the School of Agriculture, Allen drafted a description of the program and an invitation to professional artists throughout the Pacific Northwest. Allen enlisted Tom Weeks, a graphic artist in the Department of Agricultural Communications, to develop an attractive printed version along with a poster promoting the new program. Weeks' posters were to become a widely collected trademark of Art About Agriculture for many years.

The program's supporters—friends and alumni who recognized art as a universal language—have sought to encourage communication among Oregon's rural and urban residents, among people who study and manage natural resources, who produce, process, and market food, fiber, and ornamental horticultural products, and those who do not.

Art About Agriculture has become a celebration of images—inspired by land and water and their bounty—intended to help people see farms, ranches, nurseries, food, watersheds, wildlife, open spaces, and discoveries about them in a new light. It has engendered a broader collective vision for these matters in Oregon and the Pacific Northwest. This purpose has inspired many people to support and advance the work of Art About Agriculture. Certainly the artists have felt the purpose of Art About Agriculture and have responded: now more than 2,500 artists have entered works, and 156 from throughout the Pacific Northwest are represented in the permanent collection. Yet, to succeed, such an ambitious program required continuing attention of dedicated people.

Tom Allen, early juror and artist in residence, OSU College of Agricultural Sciences

Besides Tom Allen, those who have been part of managing and directing the program include Betty Brose, Debra Rarick, Mary Boyer, and the current directing curator, Shelley Curtis.

Twenty-eight individuals have served as jurors since the inception of Art About Agriculture. Typically, there are three each year. Tom Allen served 18 years as one of the jurors, from 1983 to 2000. Ten different faculty members of the OSU Department of Art have served as jurors in 16 of the 23 annual competitions. Art faculty from Lewis and Clark College, University of Oregon, and Western Oregon University also have been jurors. Five Oregon artists outside academia have been jurors, as have three gallery directors and arts advocates. Seven women who are agriculturists or involved in related fields have served as jurors in 14 of the 23 competitions. The first of these, Virginia Tubbs, was a juror for the opening show of Art About Agriculture. She recalls other duties, too, including personally driving the first show in 1983 to its exhibition in Walla Walla. It is, of course, their individual and collective judgments that have shaped the character of the annual shows and the permanent collection. (A list of these tireless volunteers appears in Appendix I.)

Galleries have been important partners from the outset. They have been both a source of fine art submissions and hosts for the traveling show. In 1983, it was first Arlene Schnitzer's Fountain Gallery that submitted work by Douglas Campbell Smith, Sally Haley, and other artists. Since then, galleries submitting work on behalf of their artists have included the Augen Gallery, Butters Gallery, Alysia Duckler Gallery, Freed Gallery, Froelick Gallery, Margo Jacobsen Gallery, Elizabeth Leach Gallery, Pulliam-Deffenbaugh Gallery, Laura Russo Gallery, Mark Woolley Gallery, and others. Hosts for the traveling show appear in Appendix II.

Long-time patrons have enabled the program to make annual awards and purchases. These patrons are recognized in the accompanying Acknowledgments section, prepared by directing curator Shelley Curtis.

Product that it is of many people's vision and dedication, Art About Agriculture would not today be what it is had not the leaders of the College of Agricultural Sciences sustained their commitment to the program. Each of Ernie Briskey's successors has chosen to support the program. They have included deans (and interim deans) Ludwig Eisgruber, Roy Arnold, C.J. Weiser, and, since 1997, Thayne Dutson. They have provided salary support for the curator, office space and equipment, student assistants, as well as understanding of the

program and advocacy for it. In return, in almost a quarter century, Art About Agriculture has indeed fulfilled the dream and vision of those who created it. It has achieved credibility in the art world of the region for its authenticity and quality; it has been the vehicle by which doors have been opened, both rural and urban, for the art to heighten awareness of agriculture, food systems, and natural resources, but also to create forums in which the art set the stage to help its viewers become more informed about public policy issues related to such things as farm policy, land-use planning, stewardship of water resources, and the like. Thus, the College has a distinct role in relation to agriculture and natural resources that extends beyond purely educating matriculated students and carrying out research. The universal need for food and for wise management of finite natural resources drives the choice of an attractive medium by which the College may illuminate and invite broader publics to consider the common good.

Now, some 23 years after Art About Agriculture was established, the College of Agricultural Sciences for the first time draws together its permanent collection of award-winning fine art and presents it, at the Oregon Historical Society in the heart of Portland, for all to see.

Juror Tom Allen announces purchase awards at the first opening reception. Eleven works of art were accessioned in 1983, marking the beginning of the OSU Art About Agriculture Permanent Collection.

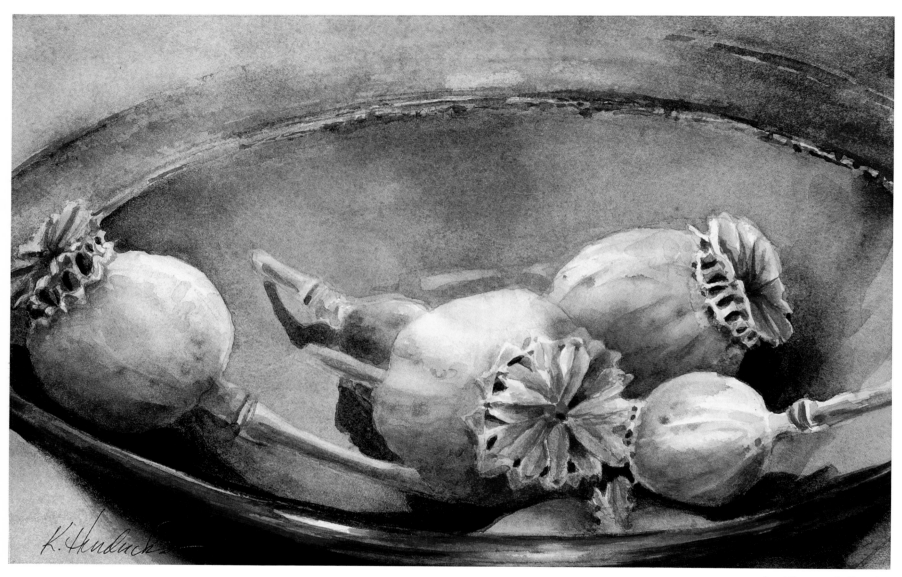

Last Summer's Poppies
Karen Hendricks

Art About Agriculture

by Lois Allan

his exhibition and its accompanying catalog, both titled, *This Bountiful Place: Art About Agriculture: The Permanent Collection,* celebrate the Northwest's extensive involvement in all aspects of agricultural production. Production begins with the natural resources from which farms, orchards, greenhouses, cattle ranches, rivers, and ocean generate the myriad foods and beverages that grace our tables. Such agricultural abundance wouldn't be possible without the work of research scientists and engineers, farmers and field workers, transporters, processors, and marketers who devote their careers to assuring continuing supplies. It is their efforts and the results of this vast and basic enterprise that are the focus of the artworks in this collection. Although artists have always recognized the beauty inherent in foods and their origins, the College of Agricultural Sciences at Oregon State University, by amassing the large permanent collection of related art by Northwest artists, has illustrated their vital economic and aesthetic importance.

From time immemorial, foods have been celebrated in art. Cave drawings in the Lascaux Caves in France, dating to the Paleolithic Era, depict animals that were the source of early humans' sustenance. Wine plays a part in Greek mythology, notably in the worship of Bacchus, known in Roman mythology as Dionysus, who was the god of all vegetation, although he is better known today as the god of vine and grape. Annual festivals held in his honor were riotous affairs with much music and dancing, considerably enhanced by the consumption of prodigious amounts of wine. Decorative drawings on amphorae confirm the fact that the importance of viticulture and the enjoyment of wine, both important to today's Americans, is nothing new.

Among the earliest images of food in European recorded history is a beautiful drawing of peaches with a glass jar that was created circa 50 A.D. on the wall of a home in the ancient Roman town Herculaneum. By surviving the disastrous Mt. Vesuvius eruption in 79 A.D., it became silent testimony to a family's love of art as well as food. It also demonstrates that art depicting foods is an ancient and time-honored tradition.

Homeward
Aki Sogabe

The many contemporary treatments of the subject are entries on this historical continuum. The artists represented in the permanent collection, all based in the Northwest, share an illustrious heritage in the recorded history of European art related to food, its production, and its necessity to human survival. Notably, an auspicious tradition began in the seventeenth century with enterprising Dutch painters. A middle class had arisen in Holland, and its affluent merchants and bankers wanted paintings for their homes, which enterprising artists, who heretofore had been dependent on patrons in the church and aristocracy, were happy to provide. For the first time, still life paintings of vegetables, fruits, and flowers became highly valued and initiated a genre that has had many permutations but has never lost its appeal. Its modernization is exemplified in the Art About Agriculture Permanent Collection by Karen Hendricks' (b. 1941) watercolor, *Last Summer's Poppies*, 2001. Hendricks' delicately colored poppy heads bring pleasant memories of last summer's bloom rather than intimating mortality, as the seventeenth century Dutch painters often did by placing one dead flower or worm somewhere in a bouquet of gorgeous flowers.

A century later another Dutch painter, now one of the best known in the world, Vincent Van Gogh (1853–1890), created two paintings that exemplify contrasting aspects of our relationships with food. The earlier of the two, *The Potato Eaters*, uses somber colors to depict a Dutch peasant family sharing a meager repast. In the other, a later painting, the beauty of sunflowers, which produce oil and edible seeds, is vividly pictured in a field of bright yellow. In the same era, the French artist François Millet (1814–1875), although not so famous as Van Gogh, painted two works, *The Sower* and *The Gleaners,* that remain popular, as the great number of reproductions attest. Both

artists' underlying theme, the clear relationship of growers and food production, is timeless, and it figures prominently in the art of areas like Oregon that have agrarian roots. Among the many artworks pertaining to this theme in the collection, Aki Sogabe's (b. 1945) paper cutting, *Homeward*, 1988, can be seen as a modern version of Millet's two gleaners. Her two figures reflect the art traditions of her native Japan translated into an Oregonian context. In a more ambiguous reference to a harvest, Mark Allison's (b. 1948) painting, *Virtual Wheat*, by distorting scale, emphasizes the production of wheat before it is processed into the flour that goes into the many commodities, starting with our daily bread, that are consumed almost universally.

The first white American pioneers to make the arduous journey to the Oregon Country from eastern states were descendants of the first European colonists. By the late nineteenth century, Oregon, only recently a state (since 1859), and far removed from the more comfortable life in eastern states, was making the most of its abundant natural resources. As its economy grew, demands increased for cultural offerings similar to those that had been left behind. Many early artists, wishing to meet the demand, came from the East. Some were self-taught, although those who were more proficient had been trained in Europe. With time, the region's colleges developed programs teaching the traditions of European artmaking to resident students. Today, Oregon assimilates many new artist-residents from foreign countries as well as other parts of the United States. All are attracted not only by economic opportunities, but also by a spectacular natural environment that is nourishing, both physically and spiritually.

This is the context from which the pictures and sculptures comprising Art About Agriculture have been created. The program began in

Virtual Wheat
Mark Allison

1983 after a few professors in Oregon State University's College of Agricultural Sciences had discussed a plan to broaden an appreciation, especially among the state's urban population, of the origins of the foods we consume. It was to be implemented through art, and to that end an annual exhibition was to be sponsored. When the necessary approvals and funding were in place, requirements governing the project were established. Each exhibition was to be juried from an open call to artists residing in the Northwest. From the exhibitions, works were selected to be maintained permanently by the College. When the collection became sizable, staff people in the College's departments, through the collection's curator, could request loans of works to display in their offices and public spaces. The result was a bonus for both the artists and the staff: the artists gained continuing display of their works, and the occupiers of offices could appreciate original artworks on a daily basis. Nonetheless, the most important measure of the collection's value is in its visual record of the region's natural resources, their cultivation, and the beauty inherent in both.

Tony Angelo in His Zucchini Field
Alan Mevis

The annual exhibitions, which are presented in several venues throughout Oregon, are selected by jurors who are artists and art professionals. The jurors also grant awards to artists for exceptional works that are then placed in the permanent collection. Even though the thematic context is a given, artists bring to it their own life experiences and observations, resulting in the great diversity found in this art collection. In describing the Art About Agriculture Permanent Collection, it would be possible to categorize the work by medium or by chronology, but a more rewarding procedure is to look at the various subject areas and the individual approaches to them. The land itself, whether in its natural state, cleared, or cultivated, is the most popular theme, followed closely by pictures featuring constructions, such as barns, houses, fences, and tools, as well as the machinery, including tractors and even airplanes, and, finally, the resulting food products. Still life arrangements, farm

The Family Farm
Marjorie McDonald

Winter Grass
Clint Brown

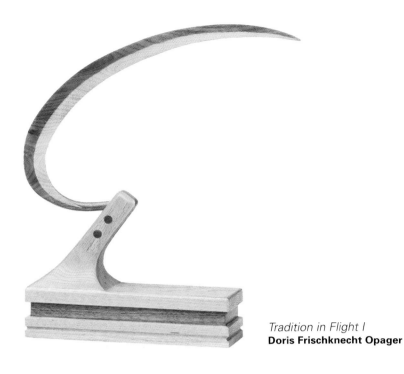

Tradition in Flight I
Doris Frischknecht Opager

animals, and humans, in addition to pictures with overlapping areas of subject matter, cannot be overlooked nor their appeal overestimated.

The artists' interpretations, their materials, their media, and their stylistic variations contribute to the aesthetic, which is to say, the formal, or visual, properties found in the artworks. They range from precise representation, such as the photograph by Alan Mevis (b. 1946), titled *Tony Angelo in His Zucchini Field*, 2003, to highly individualistic realism, as in the late Marjorie McDonald's (1898–1995) collage, *The Family Farm*, 1987, to near abstractions like *Winter Grass*, 1986, Clint Brown's (b. 1941) mixed media piece, and Tallmadge Doyle's (b. 1956) print, *Anatomy of a Honey Bee IV*, 2000 (page 103), to total abstraction as in Doris Frischknecht Opager's (1948–1987) sculpture, *Tradition in Flight I*, 1982. Peter Marbach's (b. 1956) vivid photograph, *Zinfandel Crush*, 1998 (page 152), appears to be abstract but is, in fact, a true representation of red grapes in the process of being crushed. The very close perspective in which the densely packed grapes fill the entire surface creates the appearance of an abstract work. Steel, a material not ordinarily associated with still life or food subjects, was used by sculptor Karen Rudd (b. 1965) to create a handsome representation of peas ready to be plucked from two opened pods. A small sculpture, although considerably larger than actual

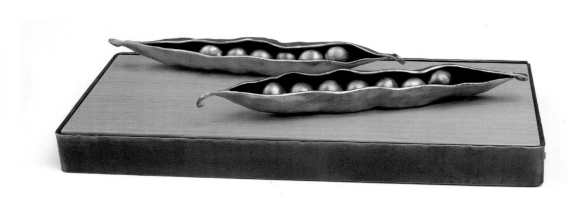

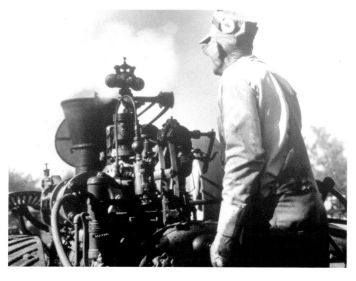

Pea Pods
Karen Rudd

Forward to the Past
Don Whitaker

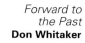

size, *Pea Pods*, 2004, can be seen formally as an abstract form holding small, perfectly formed spheres that are contrasted with the stretched oblong form. Actually representational, the sculpture visually exemplifies the saying "as alike as peas in a pod."

While there are no traditional portraits in the collection, many pictures include humans within the composition. Some have been mentioned earlier; a few others must be singled out. Yolanda Valdés-Rementeria's (b. 1949) oil painting, *Familias Campesinas*, 1994, sympathetically depicts Mexican families of agricultural workers above a field that they no doubt have cultivated. The families are gathered around the dominant figure of the mother, and all are gazing outward beyond the picture's edge, looking toward a better future. Painted in a style resembling Mexican peasant religious art, it is a reminder of the difficult and demanding labor performed by immigrant agricultural workers and of the closeness and determination of family members. A touching photograph, *Forward to the Past*, 1994, by Don Whitaker (b. 1938) features a farmer typical of Oregon's much earlier, independent farmers, an old man who looks at an equally old machine. This photograph and *Familias Campesinas*, when compared, point up

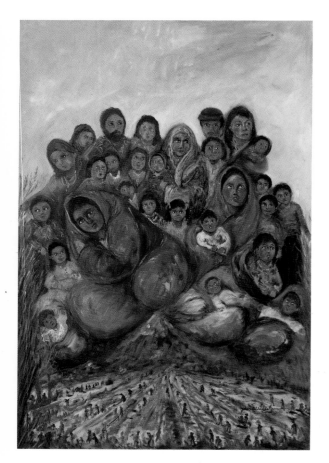

Familias Campesinas
Yolanda Valdés-Rementeria

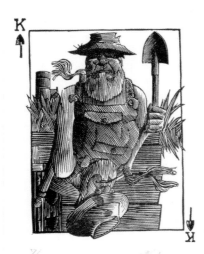
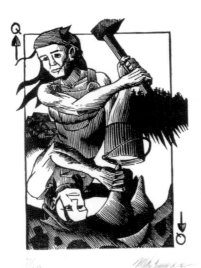

King, Queen, and Jack of Spades
Michael Lawrence

the political as well as social changes that have occurred in recent years. Agriculture has become large scale, bringing about new, advanced equipment, yet some of it still requires many field workers, who now are primarily immigrants. Even the photograph's title, *Forward to the Past*, resonates with nostalgia and sympathy for the old farmer's loss, while *Familias Campesinas* emphasizes the contribution to the economy of immigrant families and their efforts to attain the kind of future all earlier immigrants to this country also have sought.

Michael Lawrence's (b. 1980) whimsical, punning wood engraving, *King, Queen, and Jack of Spades*, 2002, is a triptych in which ordinary playing cards carry agricultural implications. In the top half of the first card, a bearded old king holds a spade in one hand, while in the bottom half his head tips downward with the hat covering his eyes, suggesting fatigue caused by heavy use of his spade.

An unusual view of the land is shown in Ian Colpitts' (b. 1940) watercolor, *Crop Duster*, 1986. The perspective is from high above the geometric fields and the airplane in the process of spraying the crops below. Rendered primarily in earth tones and accented by the plane's white emission, the roads, and the tiny buildings, it is realistic yet also reflects abstract concepts.

Crop Duster
Ian Colpitts

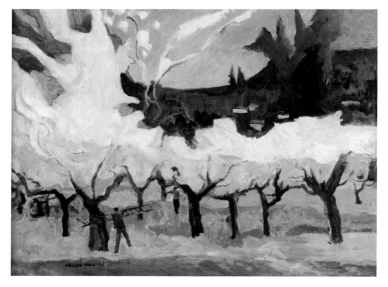

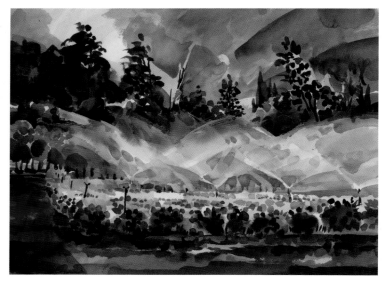

Spring Series #3
Nelson Sandgren

A Pragmatic Poetry of Mist
Erik Sandgren

Impressionistic landscapes by Nelson Sandgren (b. 1917) and his son, Erik Sandgren (b. 1952), capture the loveliness of spring in the early stages of the growing season in Northwest orchards. Nelson's oil painting, titled *Spring Series #3*, 1991, is a visionary interpretation of fruit trees in full bloom. The trees, topped with masses of white, fill the middle distance. The focus of the composition is a tree at the left, which shows its ephemeral cloud of white ascending to the sky, where it seems to break up and become small clouds. Erik's watercolor, *A Pragmatic Poetry of Mist*, 2001, also has a pastel-inflected white middle distance that is caused, not by flowering trees, but by arched sprays of water above a low-growing green crop. The sky is rendered in diagonal shafts of blue that seem to descend through the tall evergreen trees in the background to the misting spray from the sprinklers.

In another popular area of subjects, images of animals attract close observation. In this category, Claire Barr-Wilson's (b. 1947) fanciful anthropomorphic clay sculpture, *Salmoneo and Mooliet, War on the Range*, 1997, a formally dressed salmon and cow stand upright on a columnar pedestal encircled by a painting of the river and range they inhabit when not attending a social event as guests rather than entrées. In a more serious vein, Sally Cleveland's (b. 1952) small painting, *Cows Mass Around the Tree/Light Through the Fog*,

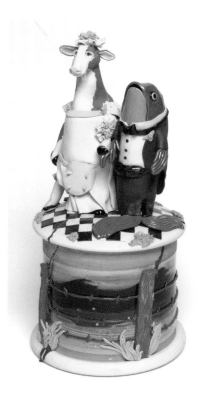

Salmoneo and Mooliet, War on the Range
Claire Barr-Wilson

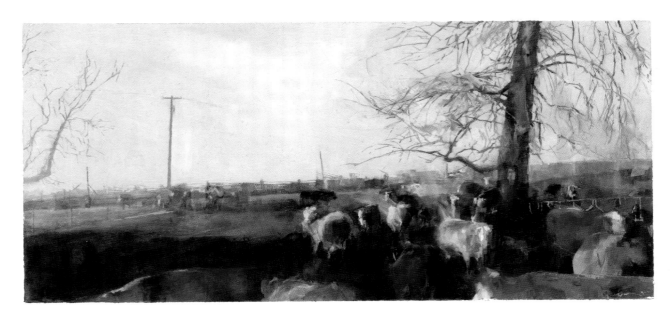

Cows Mass Around the Tree/Light Through the Fog
Sally Cleveland

2000, establishes a context for the herd of cows dominating the foreground by placing distant fields in the middle ground, as well as a background in which a wide pale sky is marked by a column of rising white smoke. A bare tree standing within the herd, a tall power pole, and the stream of smoke in the distance are not only vertical anchors for the composition, but also are reminders of the energy—technical as well as natural—required to produce cattle. Though small, the vista in the painting indicates dimensions more often seen in very large paintings.

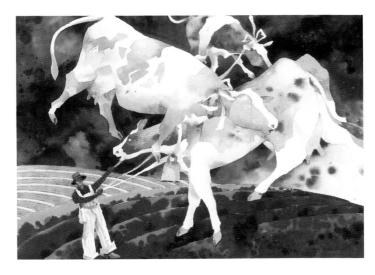

Oh Buttermilk Sky
Muriel Pallay

In another depiction of cows in Muriel Pallay's (b. 1939) *Oh Buttermilk Sky*, 1992, a farmer standing in his field holds tethers to cows much larger than he as they float off into the sky. The painting is reminiscent of the fantastical visions of the internationally renowned artist Marc Chagall (1887–1985), who captured viewers' imaginations with paintings of animals and people floating over the rooftops of Jewish villages in his native Russia.

Sheep
Kevin Clark

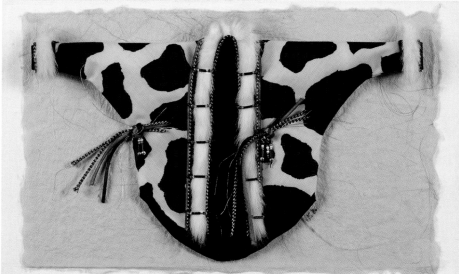

Bovine Dinner Jacket for the Annual Feed and Dance
Judith Sander

Sheep are the subject of Kevin Clark's (b. 1964) woodcut print of the same name, completed in 2004. The print is so small and the sheep so crowded together, this charming little print might be overlooked if it weren't for the innovative presentation. The felt mat for the print features a wire placed on all four sides that alludes to the sheep's pen.

The strong presence of crafts in Oregon is undoubtedly rooted in our pioneer past. Today crafts are widely used in sculptural as well as functional works. Excellent training for craft artists is provided by the Oregon College of Art and Craft, which has not only trained artists, but also exhibited clay, metal, fiber, and wood artworks since its founding in 1907. Several galleries throughout the state, including the prominent Contemporary Crafts Gallery and Museum in Portland, specialize in exhibitions of artists working in the craft tradition. Clearly, the Art About Agriculture Permanent Collection wouldn't be complete without the inclusion of pieces employing craft materials and deriving from this tradition. Already mentioned, *Salmoneo and Mooliet, War on the Range* is one of the collection's several clay sculptures. Another popular one, *Farmhand*, was created in 1983 by ceramicist Barbara Anderson Bond (b. 1945). A realistic representation of an actual-size boot, the sculpture lies on its side as if its wearer has just pulled it off.

Three fiber pieces by Judith Sander (b. 1947), *Clara Bell's Cow Chip Coat,* 1986 (page 178), *Bovine Dinner Jacket for the Annual Feed and Dance,* 1985, and *Zeke's Ceremonial Jacket for Chicken and Egg Gathering,* 1988 (page 179), are amazingly detailed, small replicas of jackets in decidedly Western designs. Labeled "mixed media," they are a combination of fur, silk cords, and myriad tiny ornamental items sewed onto a backing of a natural colored cloth. Equally intriguing in its offbeat verisimilitude, an amusing soft sculpture, *The Eternal Watch,* 1982, by Mary "Molly" Murphy (b. 1952), imaginatively represents a full size, hulking vulture. Constructed from clothing materials that have been quilted, puckered, and pieced, the "vulture" seems to be observing its prey from the safety of a gallery pedestal.

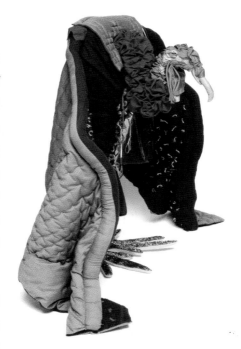

The Eternal Watch
Mary "Molly" Murphy

Many more visual pleasures can be found in the great variety among the almost 200 artworks that comprise the collection. All are included in the 2006 exhibition at the Oregon Historical Society in Portland, Oregon, and all are illustrated in the catalog. Both the exhibition and the catalog provide viewers and readers with a lasting documentation of regional art produced within a given period of time with a particular focus. Art About Agriculture does not intend to challenge its viewers, as so much avant-garde work does, but rather, its purpose is to celebrate the earth's bounty and the energy, commitment, and persistence of the many workers who bring from it our life-giving sustenance. The collection covers far-reaching subject matter that encompasses every aspect of agricultural production, starting with natural resources—the soil itself plus the water and the climate necessary to its cultivation. It also encompasses animals and fish as well as all the humans engaged in their most basic and essential toil.

Beyond its specific theme, the Art About Agriculture Permanent Collection is a record of the evolution of regional artmaking: the various media, the techniques and processes, the materials, and the styles that are used by today's artists. The media range from some of the oldest, such as woodcuts and wood engravings, exemplified by Paul Gentry's

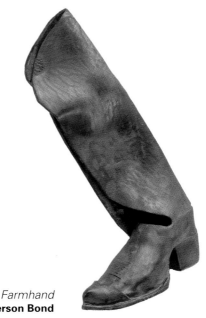

Farmhand
Barbara Anderson Bond

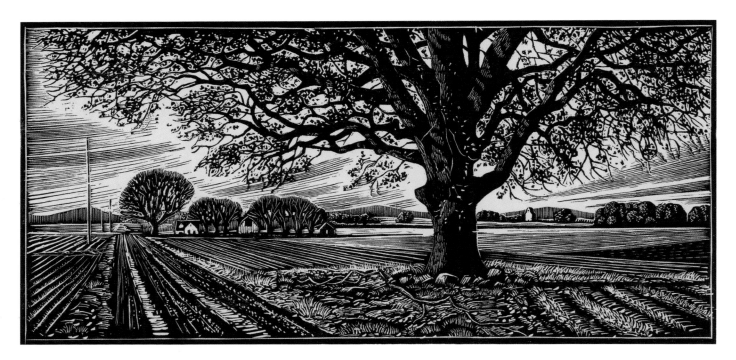

Willamette Country
Paul Gentry

(b. 1954) wood engraving, *Willamette Country*, 2003, to the newest, the digital prints produced by computers, as seen in Charles True's (b. 1948) unusually formatted picture, *Filbert Orchard at Sunrise*, 2000. Watercolors and paintings, both oil and acrylic, abound, while a newer medium, photography, both film and digitized, is now recognized for its artistic merit. Clay, wood, and steel are the materials of the few small sculptures in the collection. Barbara Anderson Bond's well-worn boot is an amusing example of the verisimilitude that can be achieved in a clay sculpture.

Filbert Orchard at Sunrise
Charles True

Rhody 4
Rick Bartow

The simplest medium, pencil, was used by Claudia Cave (b. 1951) in her elegant, monochromatic grid drawing, *Palouse Wheat*, 1996. Mixed media works on paper include a delicate and beautiful graphite and gouache drawing, *Rhody 4*, 1997, by Rick Bartow (b. 1946). It's in the tradition of classic Renaissance naturalism, a period that inspired such artworks as the late fifteenth-century botanical studies of Leonardo da Vinci (1452–1519). Since the Renaissance itself heralded scientific inquiry that was closely associated with the period's aesthetic discoveries and applications, selecting Bartow's historically relevant drawing for the 2005 Art About Agriculture signature artwork and annual poster was clearly an appropriate choice.

Palouse Wheat
Claudia Cave

There was a time when artists were expected to render their subjects in the truest representation possible. Early in the twentieth century the primacy of that style was abandoned, due in large part to remarkably innovative artists, who, like Pablo Picasso (1881–1973), chose radically different means of depicting their subjects. Various forms of European modernism, including Impressionism, Cubism, Fauvism, German Expressionism, and other lesser-known styles, were followed by the seminal movement, Abstract Expressionism, which originated in New York in the 1940s. In the eclecticism of contemporary art, adaptations of all those movements can be seen. New materials, new concepts, new ideas of both aesthetics and subject matter have come about, and many are evident in the collection.

But the lasting impression gained from perusing the works in the Art About Agriculture Permanent Collection, from both the exhibition at the Oregon Historical Society and this catalog, is that of the compelling beauty, whether rugged or verdant, of the land in all seasons, all weather, and all formations. The land, rivers, lakes, and oceans are the first essential in sustaining the huge industry that produces the plethora of foods we consume, the fibers we depend upon, and the ornamental plants we enjoy. If there is an underlying message in these artworks, it is the necessity of good stewardship of the area's natural resources so that they can be used judiciously and enjoyed in perpetuity.

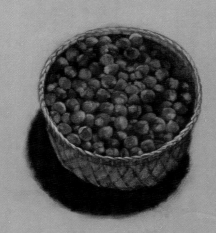

Filberts
Sally Haley

Painting

Virtual Wheat
Mark Allison

The Red Bowl
Amy Beller

The Winged Seeds
Harry Bennett

Impending Summer Storm, Wheat Fields
Berkley Chappell

Abandoned Barn
Mark Clarke

Cows Mass Around the Tree/Light Through the Fog
Sally Cleveland

Grand Farm View
Bets Cole

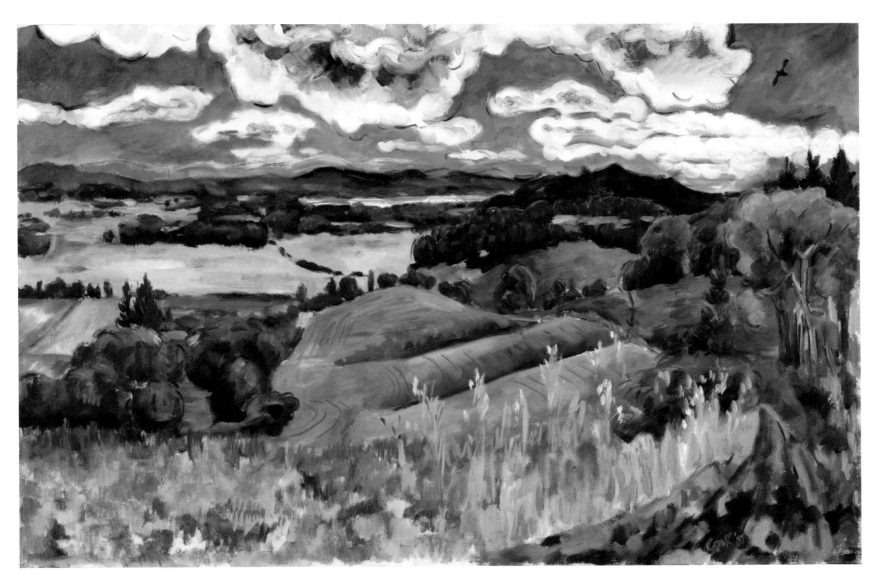

Cheshire, Oregon
Andrew Cook

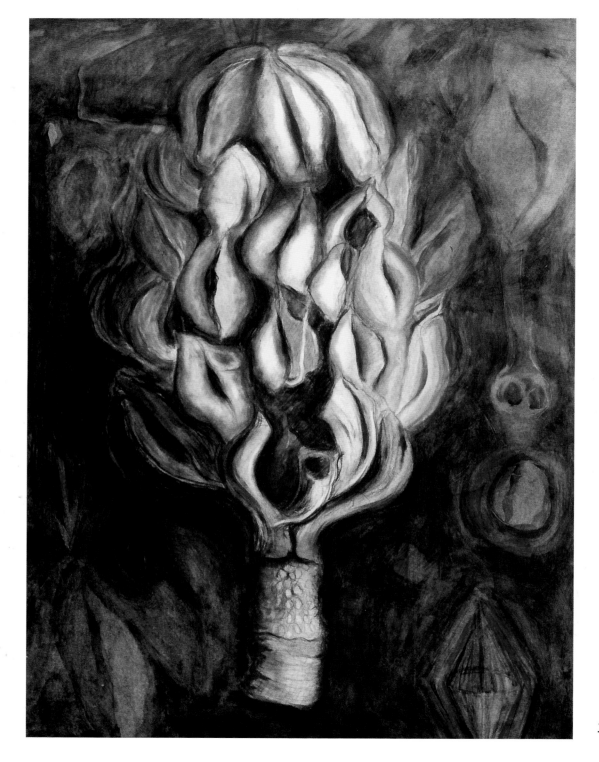

Seed Pod II
Tallmadge Doyle

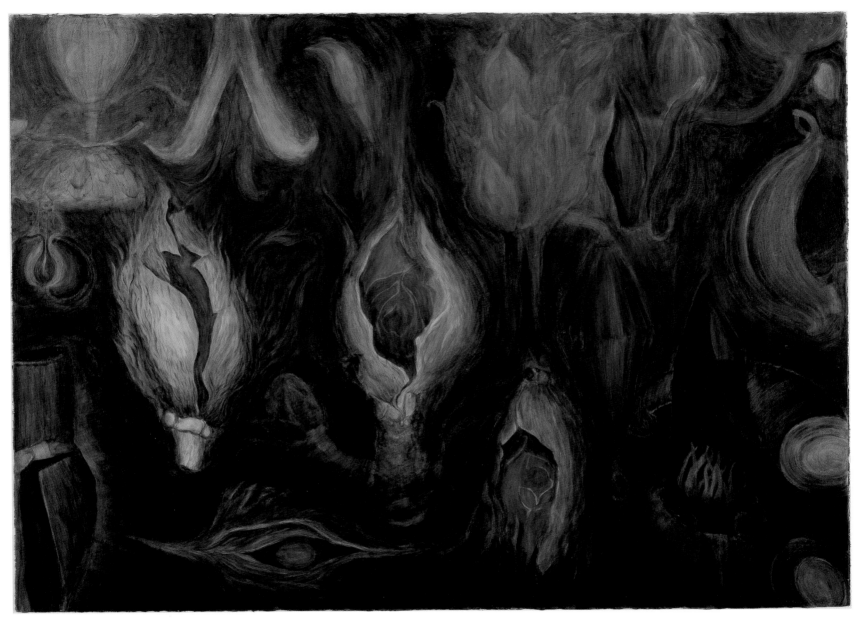

Assorted Buds
Tallmadge Doyle

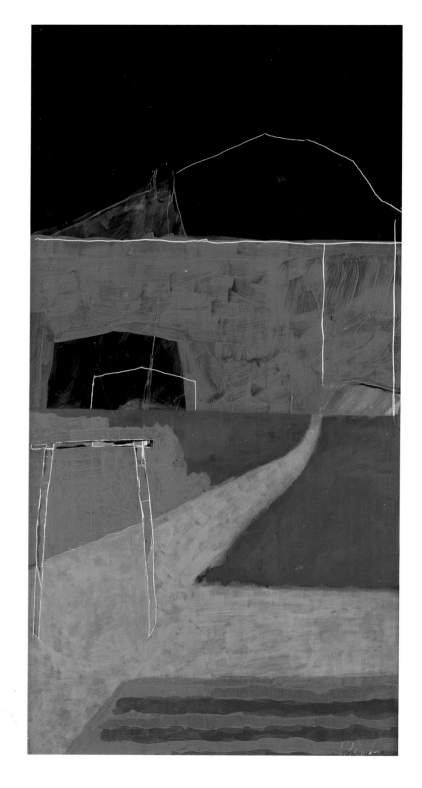

Threshold
Jeana Edelman

Outside Sheridan
Priscilla Hanson

Sheep Grazing Near Amity
Edwin Koch

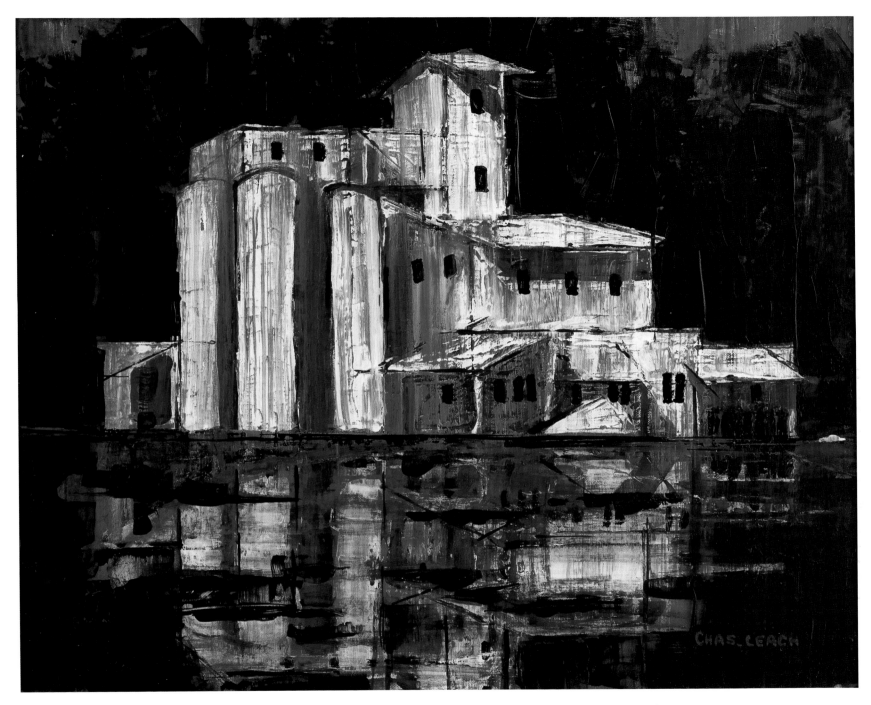

Reflections on Time
Charles Leach

Tree Farm
Erik Scott Nelson

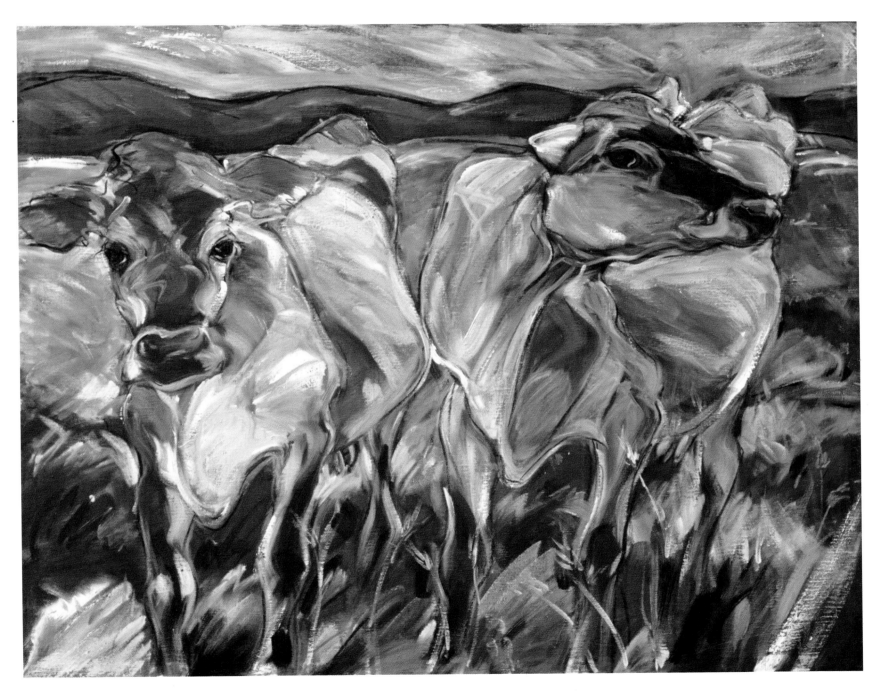

Green Cows
Heidi Olsher

Higbee Farm
Richard Robertson

Peoria Wheat Fields
John Rock

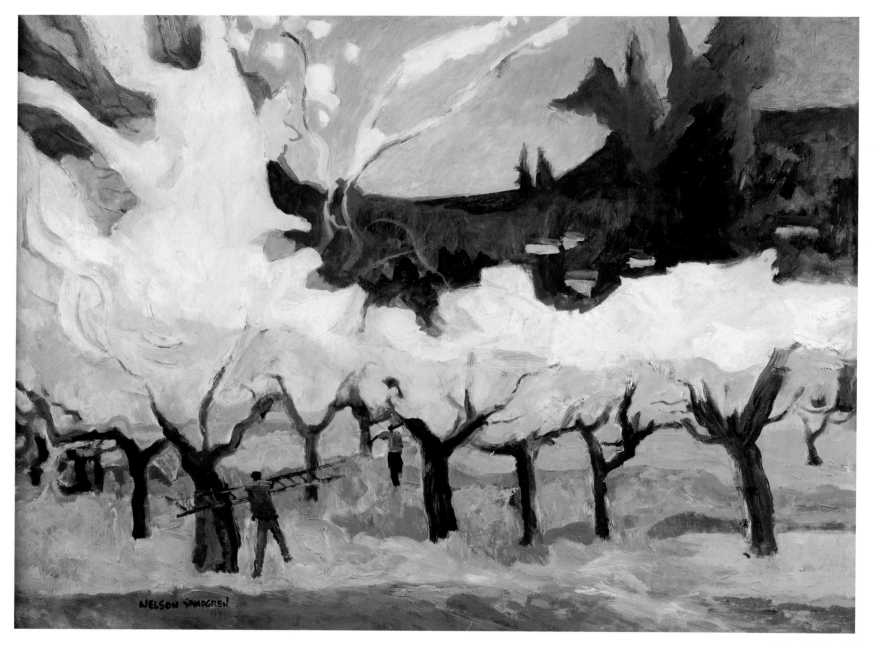

Spring Series #3
Nelson Sandgren

Bocca Marsh
Douglas Campbell Smith

Grain Elevator
Robert Schlegel

Ebey's Prairie Farm, Whidbey Island
Donna Trent

Winter Wheat Growing
Donna Trent

Canal in March
Phyllis Trowbridge

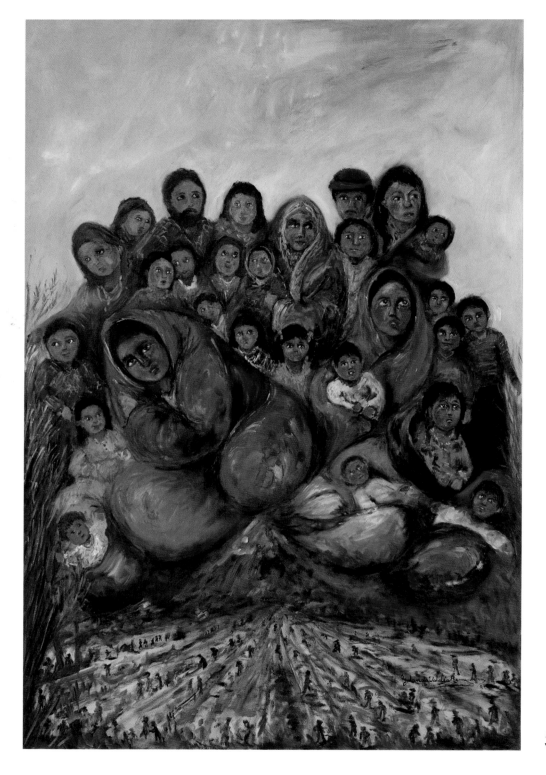

Familias Campesinas
Yolanda Valdés-Rementeria

Dawn After Storm
Elise Wagner

In the Mill
Robert Weller

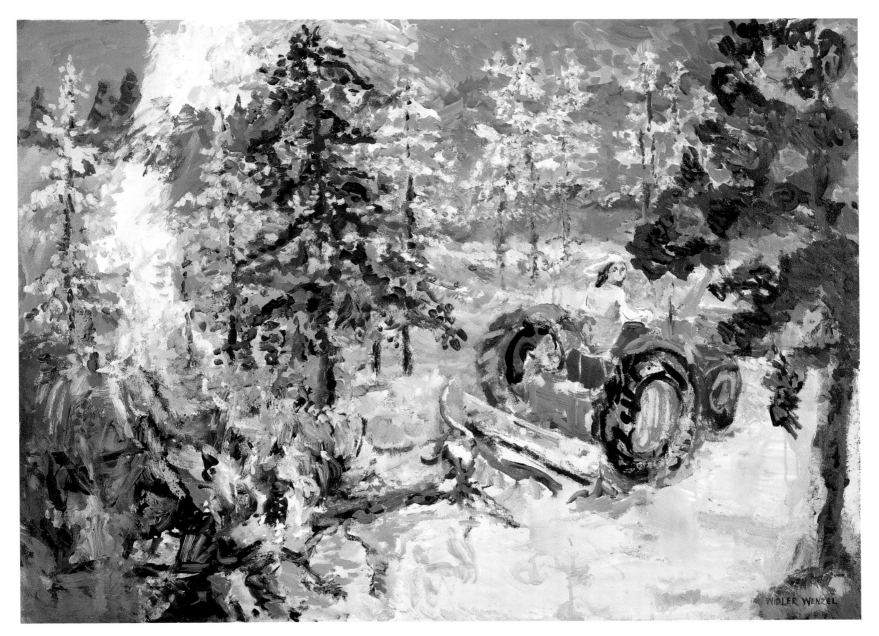

Mother Thinning Woodlot
Diane Widler Wenzel

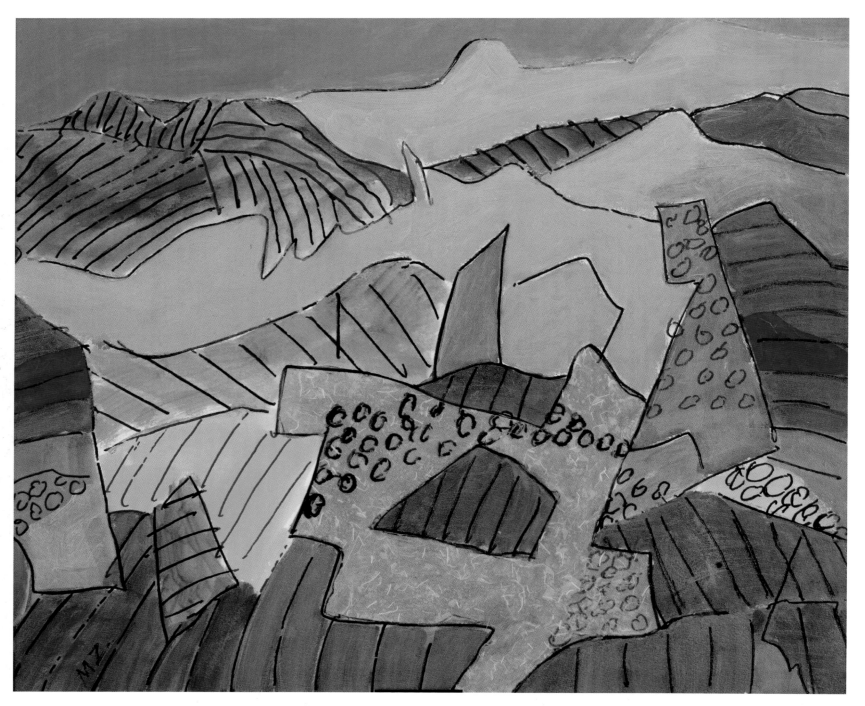

Patterns in Agriculture
Mark Zentner

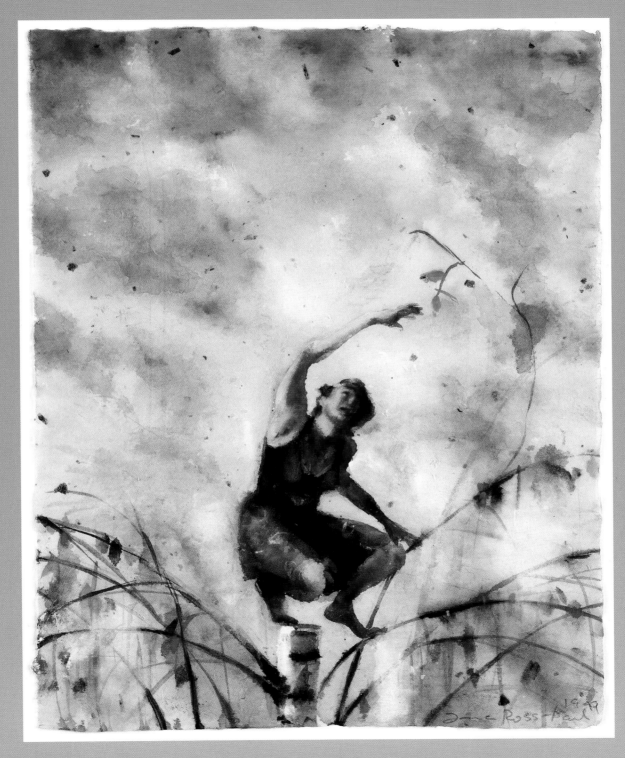

Find
Laura Ross-Paul

Watercolor

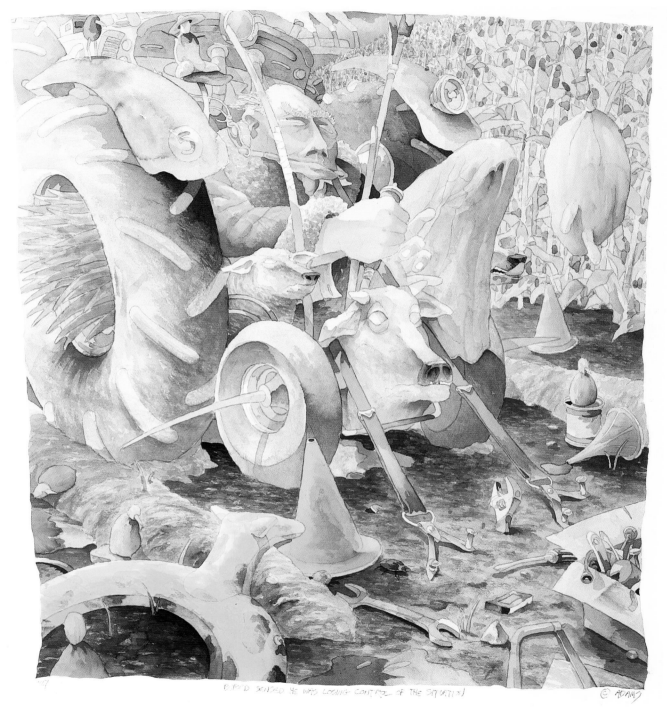

Buford Sensed He Was Losing Control of the Situation
Jim Adams

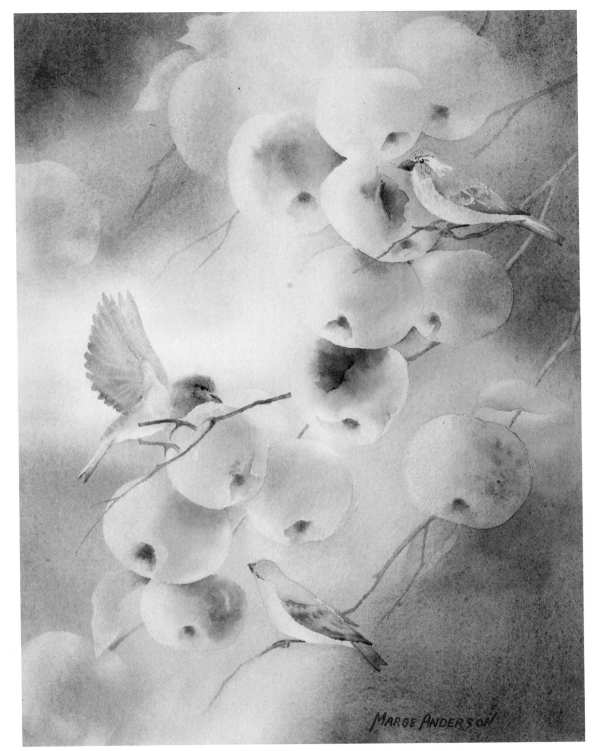

An Apple a Day
Marge Anderson

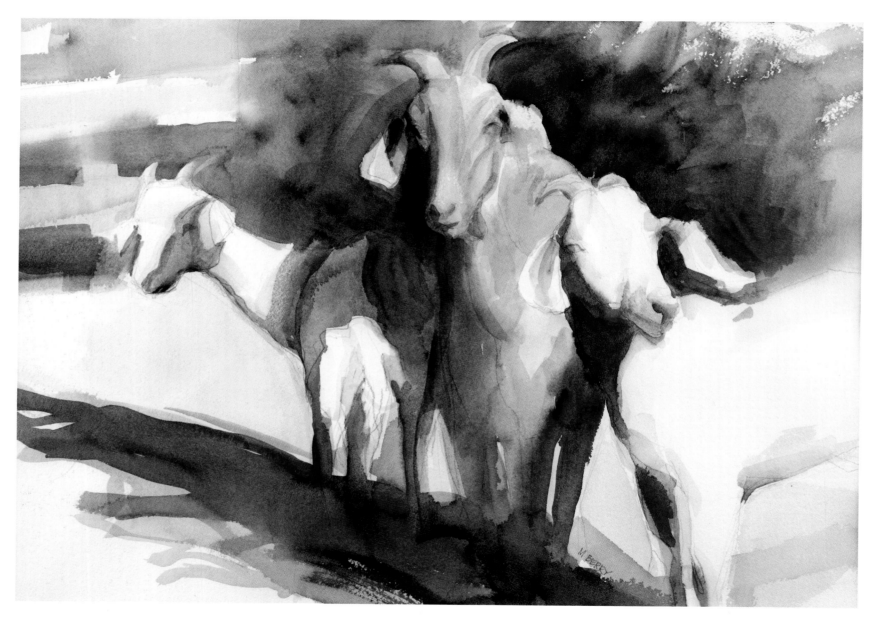

Heidi and Friends
Mary Berry

Fall Farm
Bets Cole

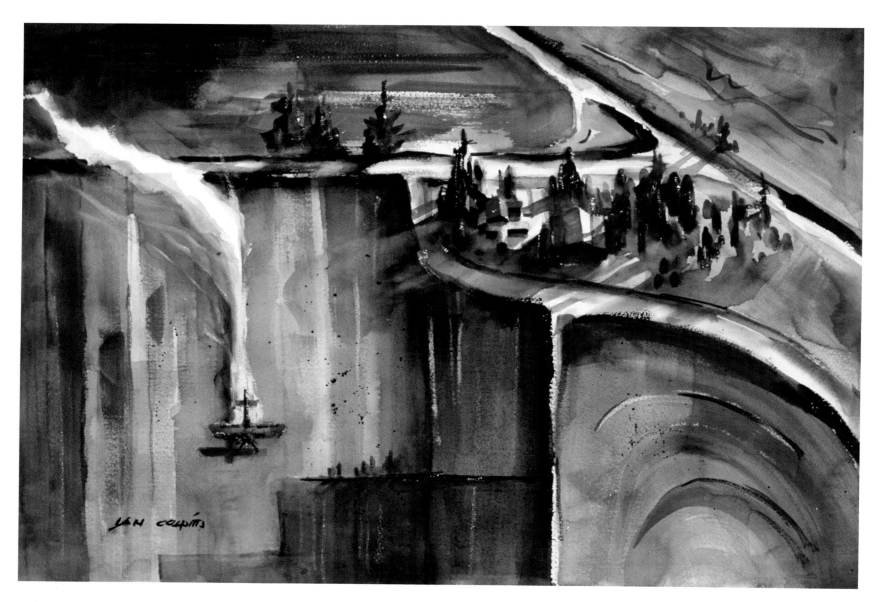

Crop Duster
Ian Colpitts

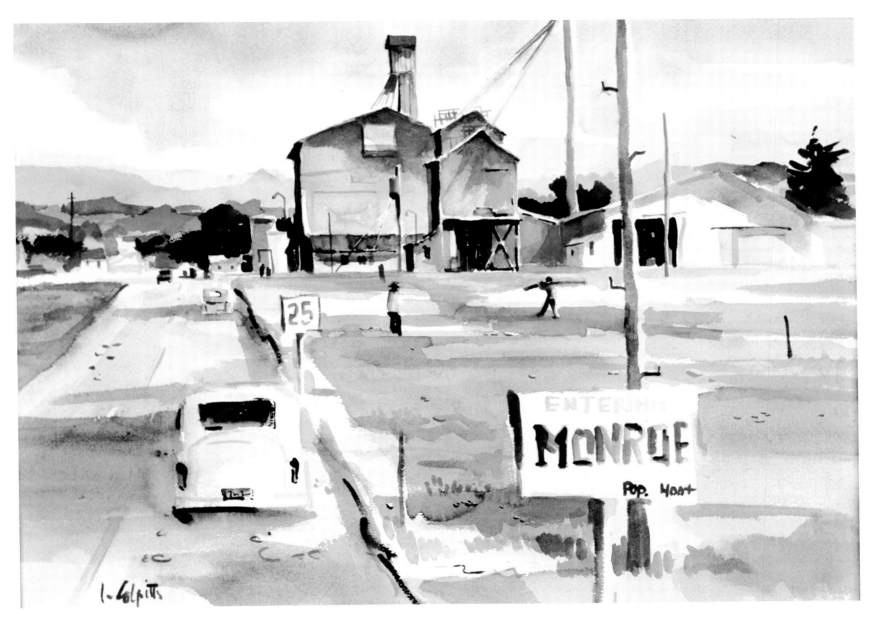

Monroe
Ian Colpitts

The Islanders
Susan Cowan

Bird's Eye View of Agriculture
Judy Findley

Snow Peak Orchard
Humberto Gonzalez

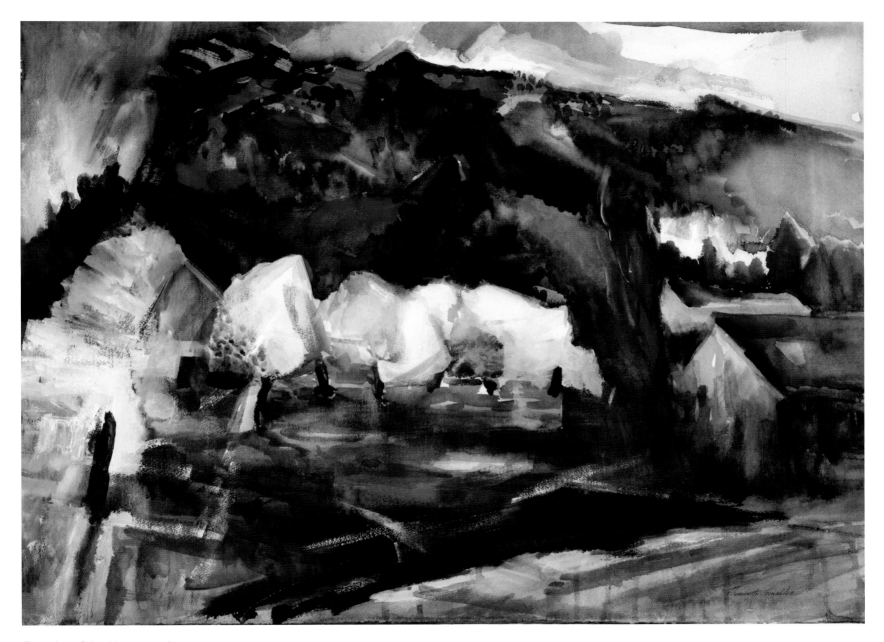

Remains of the Homestead
Humberto Gonzalez

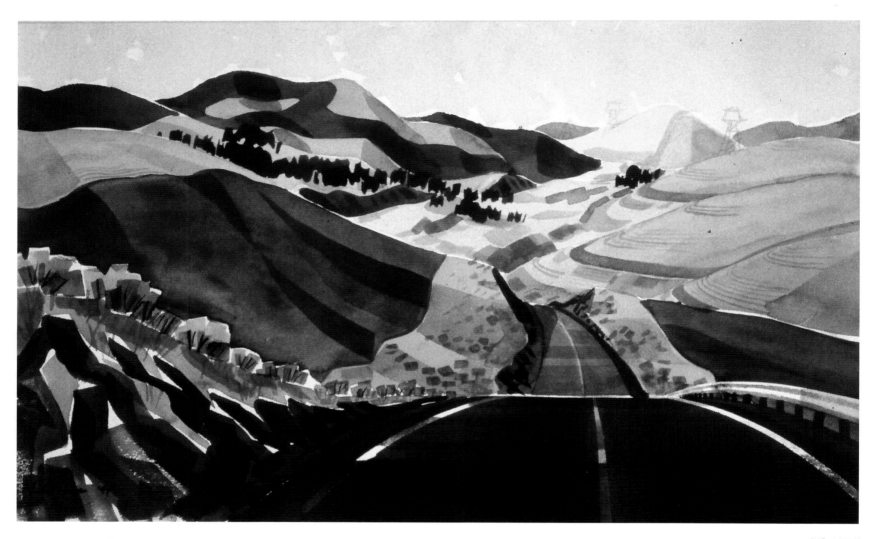

US 197 II
Allen Greene

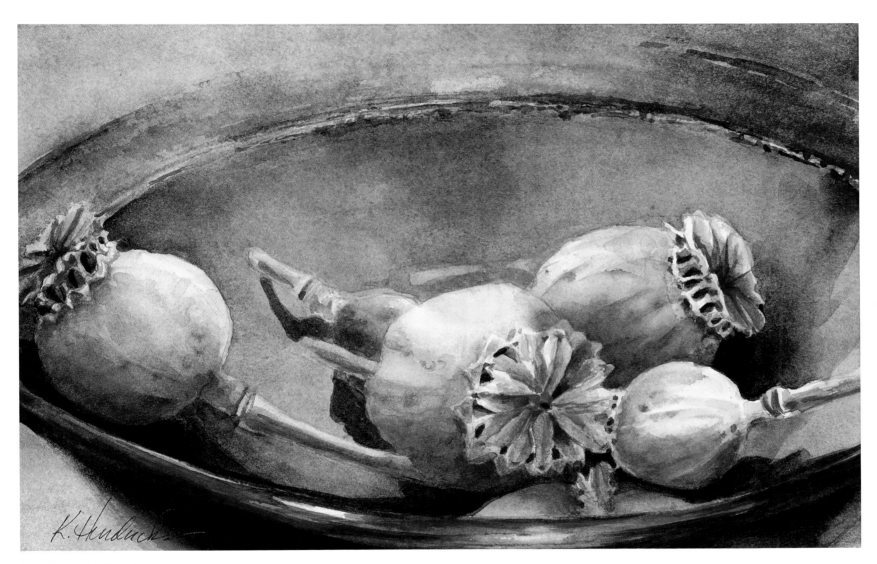

Last Summer's Poppies
Karen Hendricks

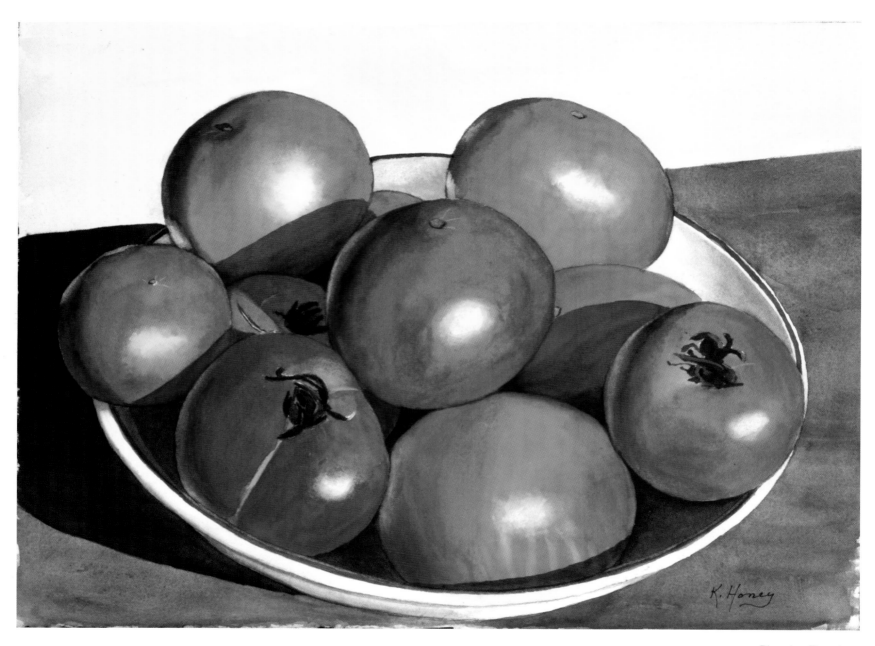

Ripening Tomatoes
Kathryn Honey

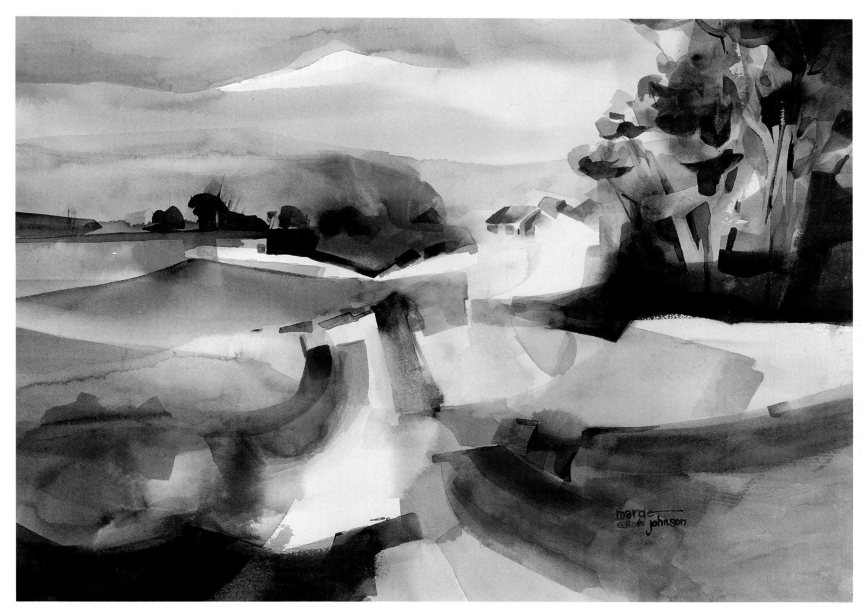

Clear Color Farm
Marge Johnson

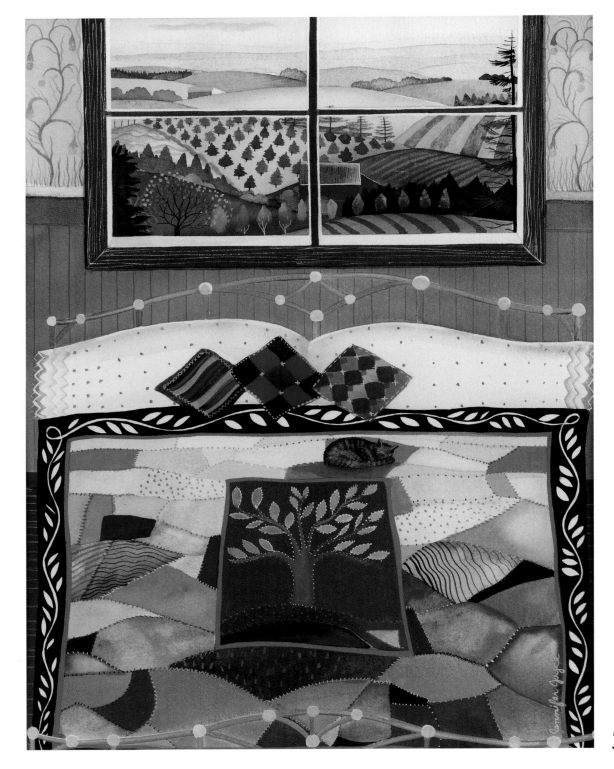

Patchwork
Jennifer Joyce

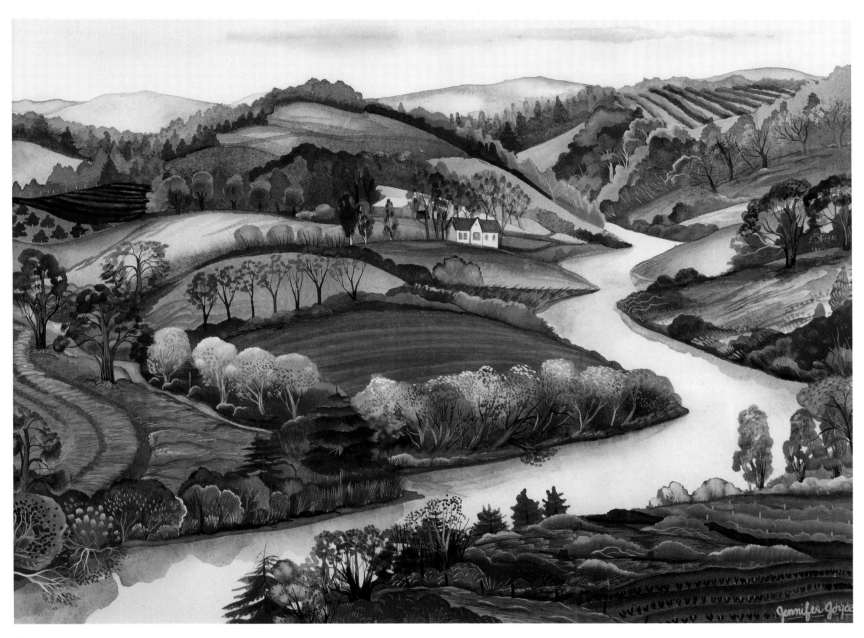

Southern Exposure
Jennifer Joyce

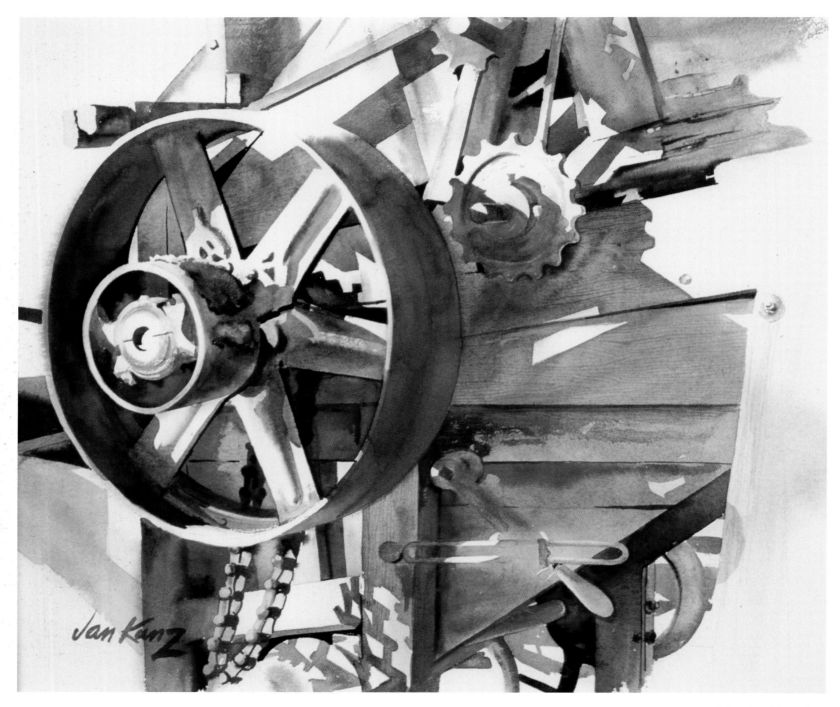

Wheel and Sprockets
Jan Kunz

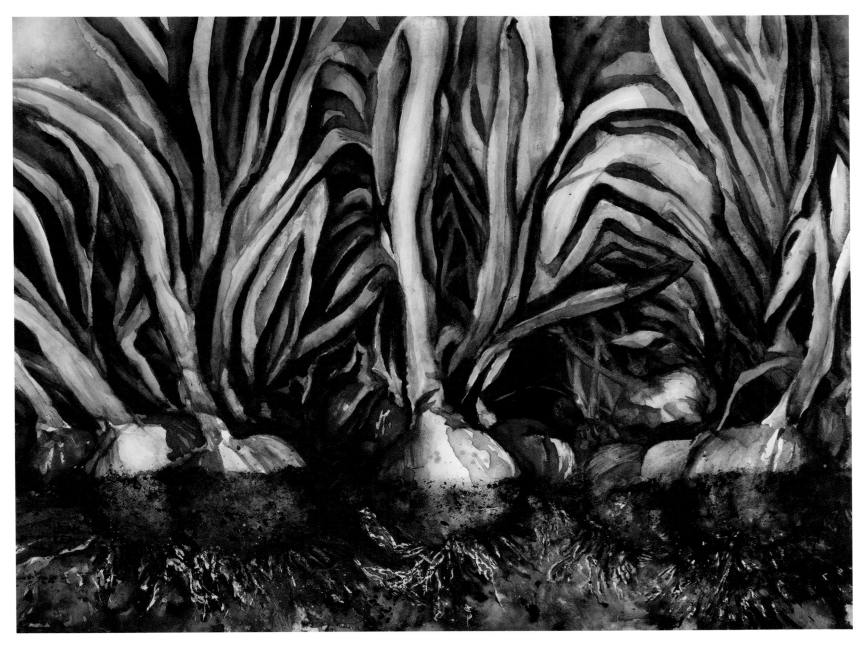

Night Growth
Jean Lea

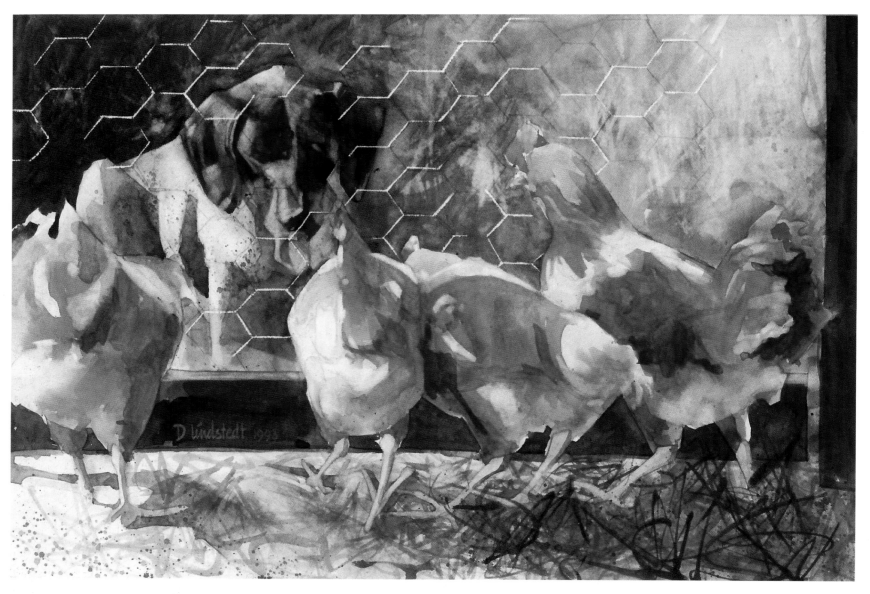

The Day Willow Met the Girls
Doreen Lindstedt

Blue Border
Bill Marshall

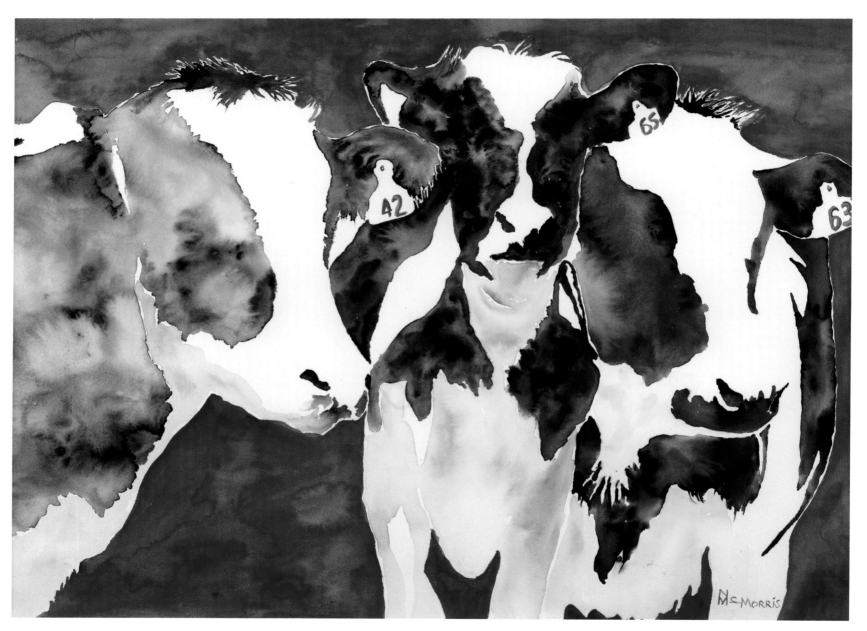

The Ladies of Thistle Hill, Nos. 42, 65, 63
Nancy McMorris

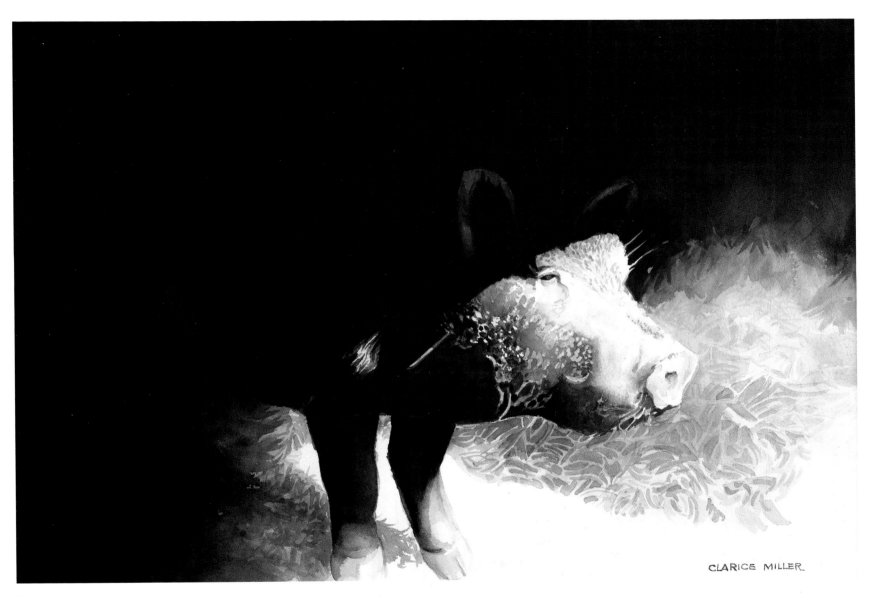

Showtime for Pot Belly
Clarice Miller

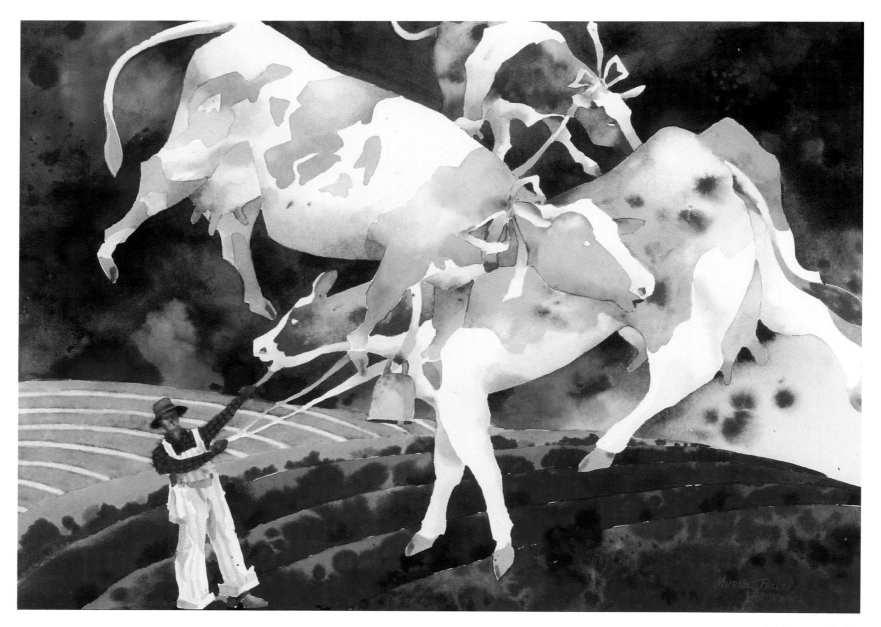

Oh Buttermilk Sky
Muriel Pallay

Yesterday's Tools
Mary Anne Pauletto

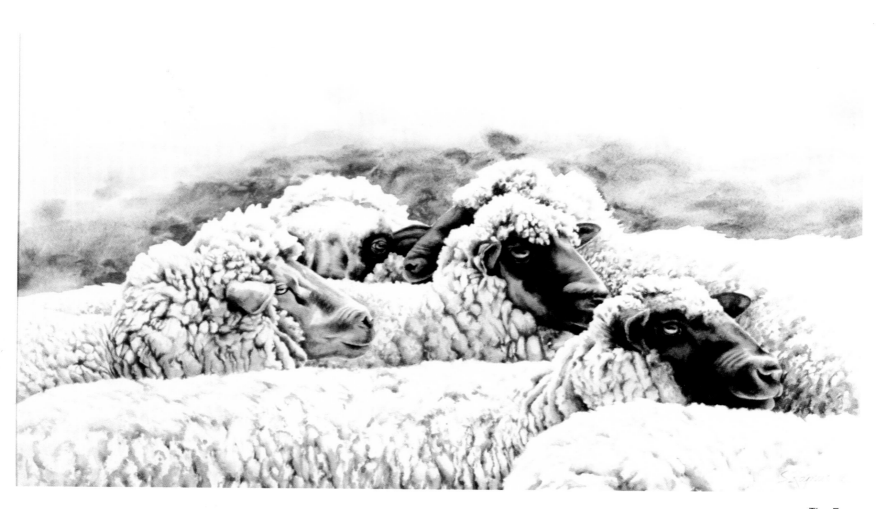

The Ewes
Sharon Rajnus

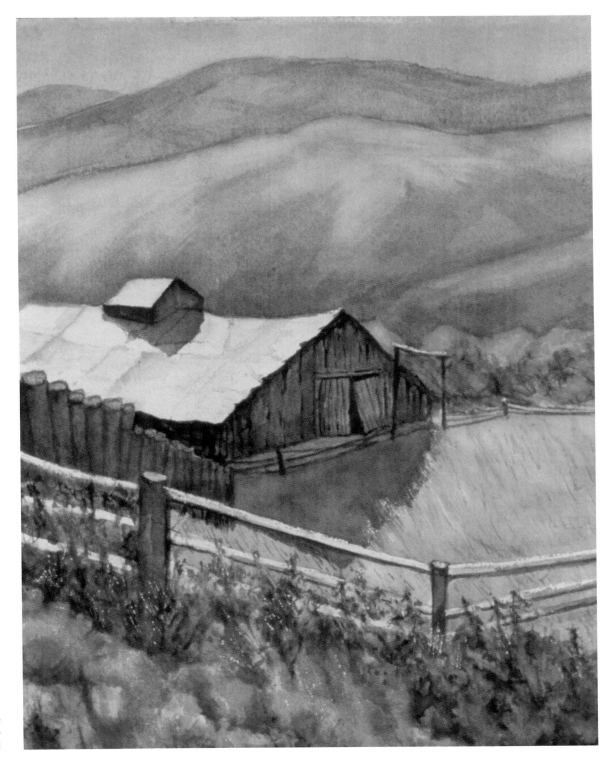

*Sheepsheds
at High Noon*
Marie "Lid" Rhynard

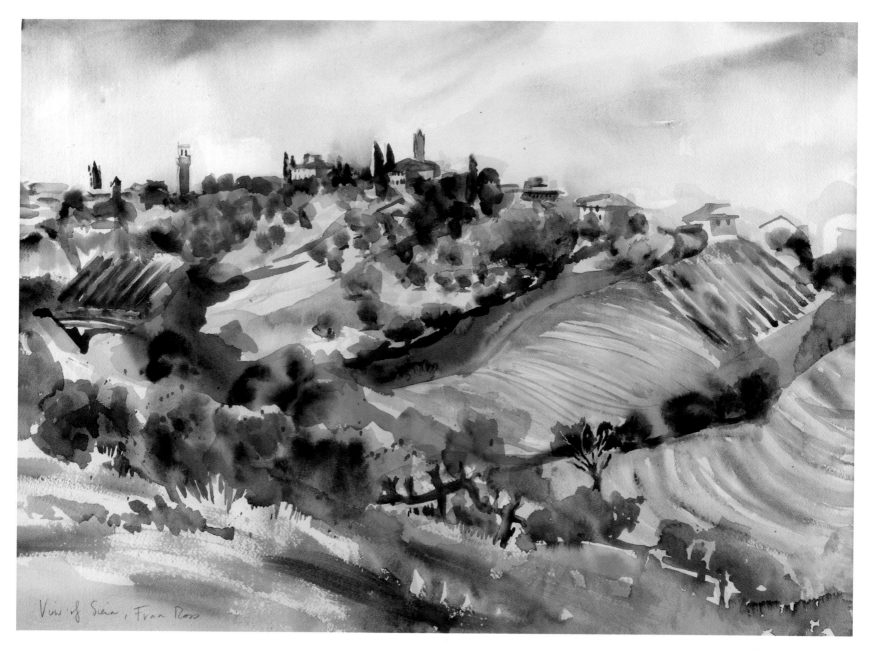

View of Siena, Fran Ross

Hilltop View of Siena
Frances Ross

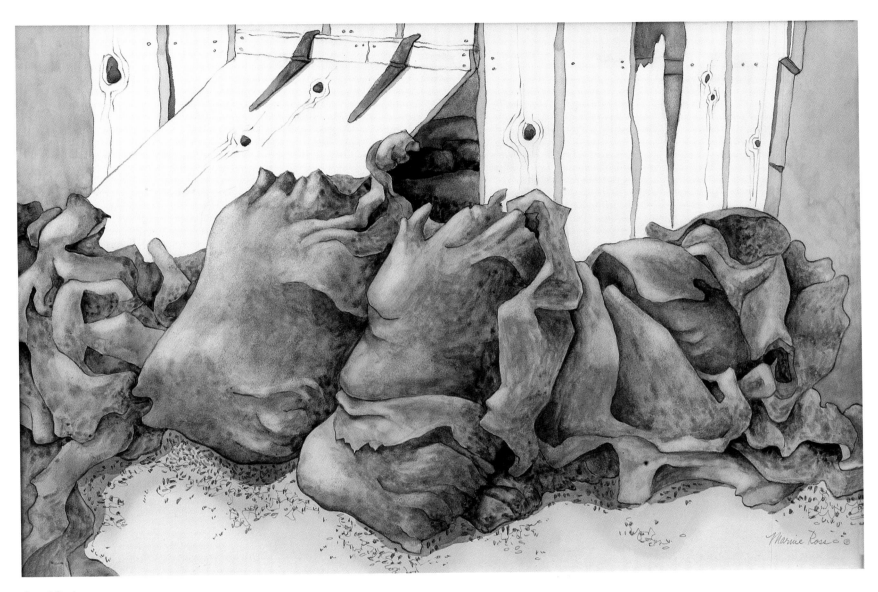

Seed Sacks
Marnie Ross

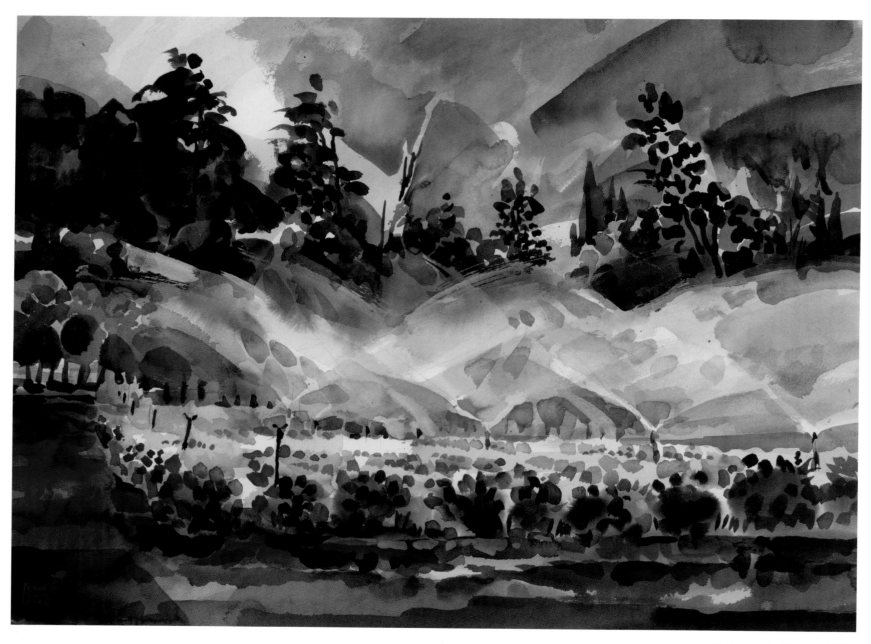

A Pragmatic Poetry of Mist
Erik Sandgren

Farm Road
J. Elizabeth Santone

Edgefield Farm
Kim E. Smith

Tualatin Vineyard II
Susan Trueblood Stuart

Fall Farm
Harold R. Walkup

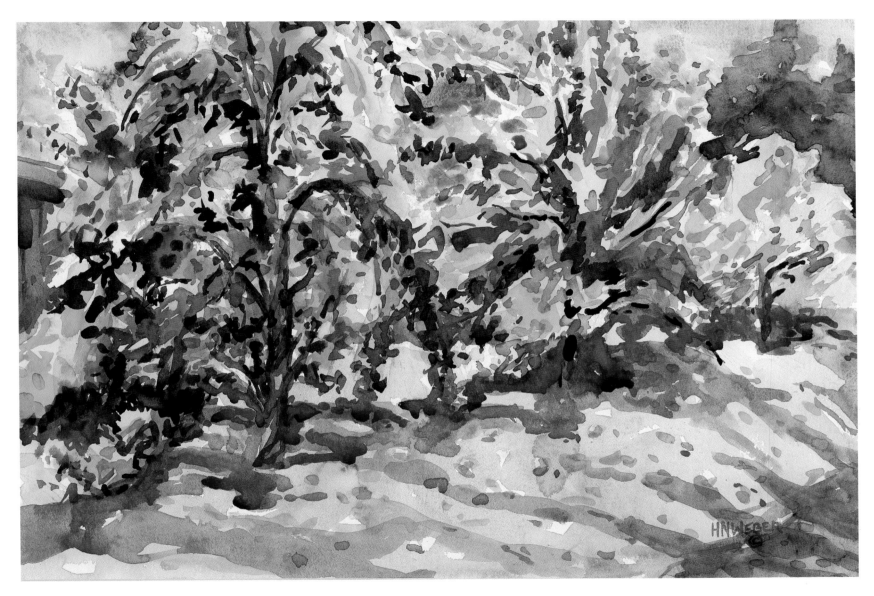

Pear Trees and Hot Shadows
Hank Weber

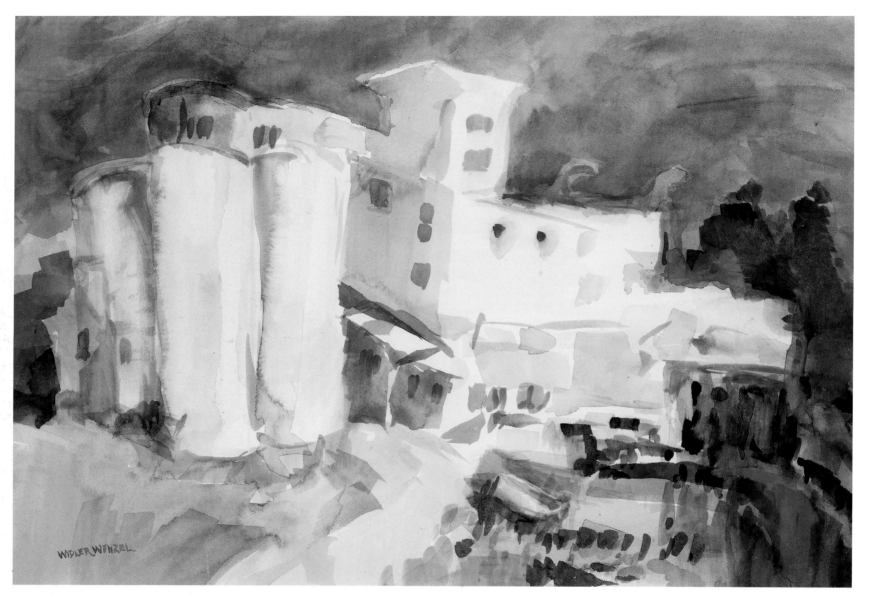

Old Boston Flour Mill
Diane Widler Wenzel

Primary Cut
Janet Sullivan

Drawing

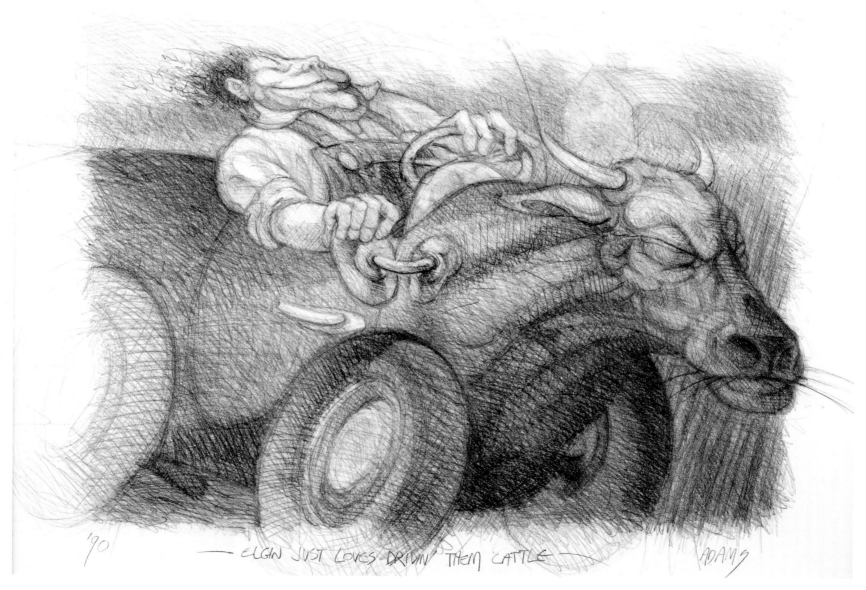

Elgin Just Loved Drivin' Them Cattle
Jim Adams

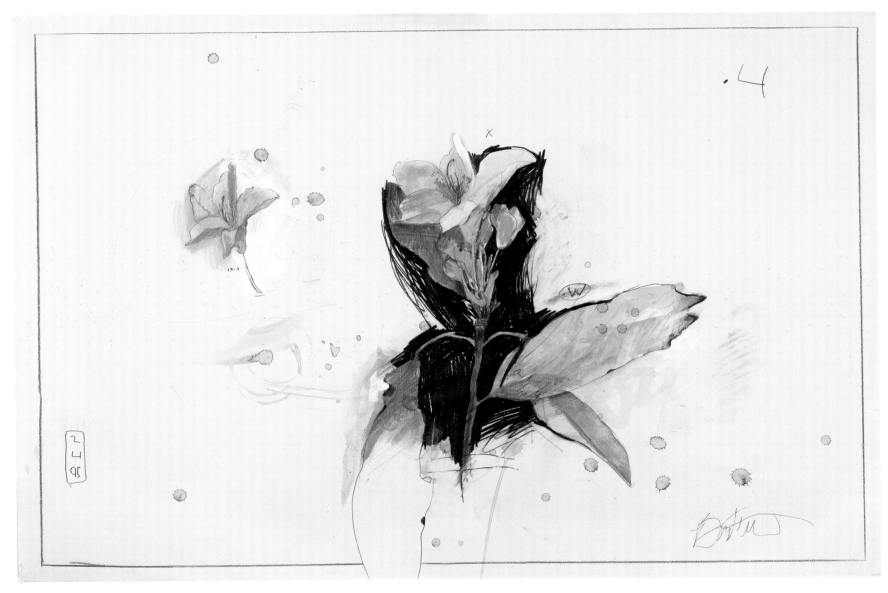

Rhody 4
Rick Bartow

Harvest Weave
Douglas Campbell

Palouse Wheat
Claudia Cave

Getting an Early Start
Chris Cummings

Persevere
Chrissy Froese

Composition II
Andrew Haley

From "Flower" to Food
Susan Johnson

Shepherd's Nightmare
Tom Kramer

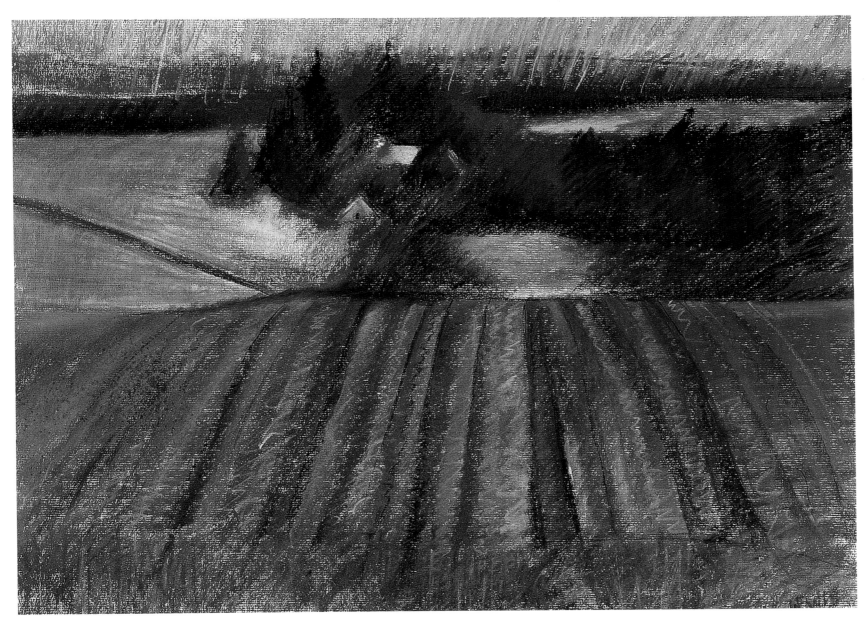

Wet Green
Susan Lewis

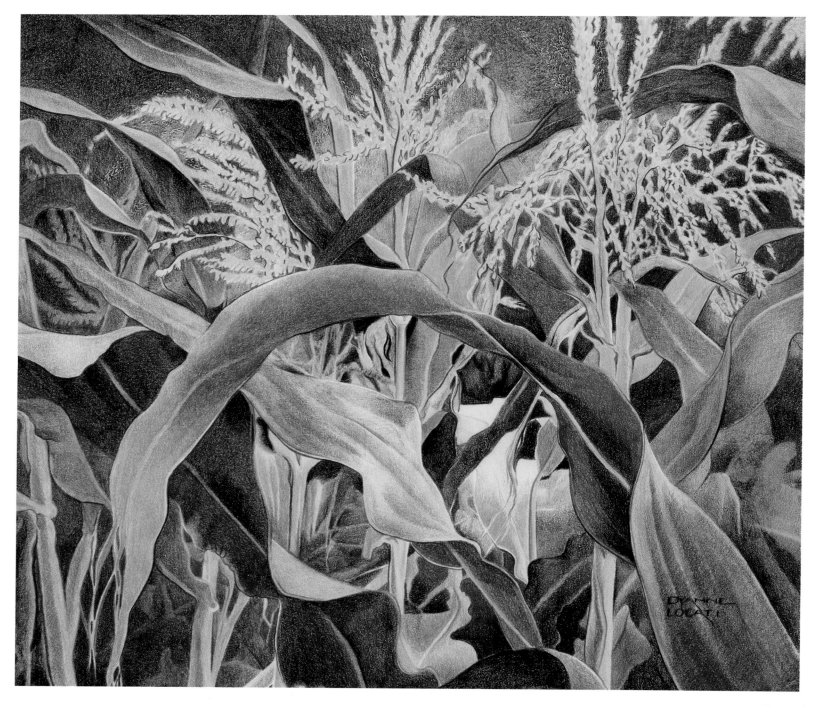

Tassels
Dyanne Locati

Vegetables
Carol Riley

Strawscape
Maurice A. Van

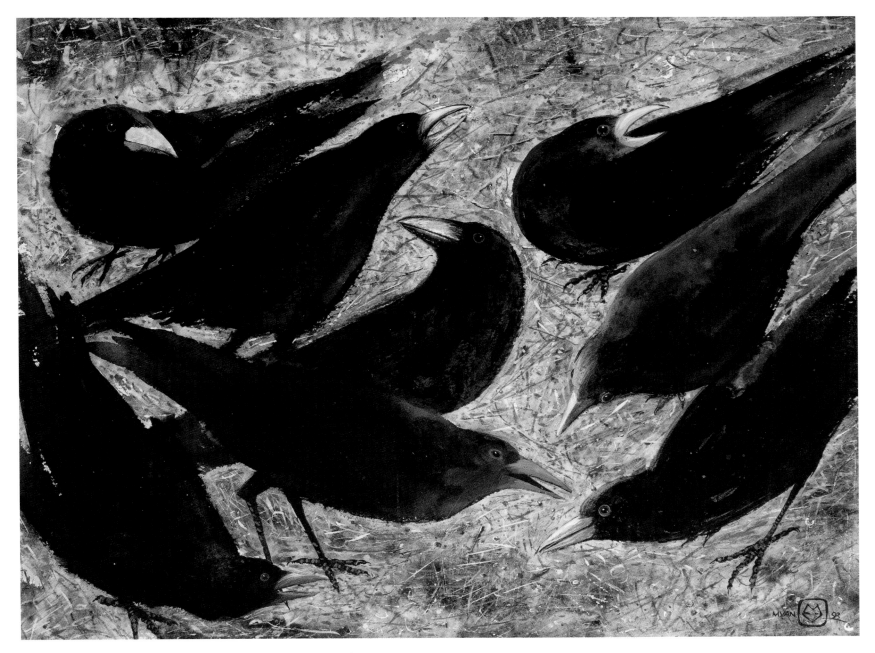

Crows in a Winter Field
Maurice A. Van

Season's Edge
April Waters

Anatomy of a Honey Bee IV
Tallmadge Doyle

Print

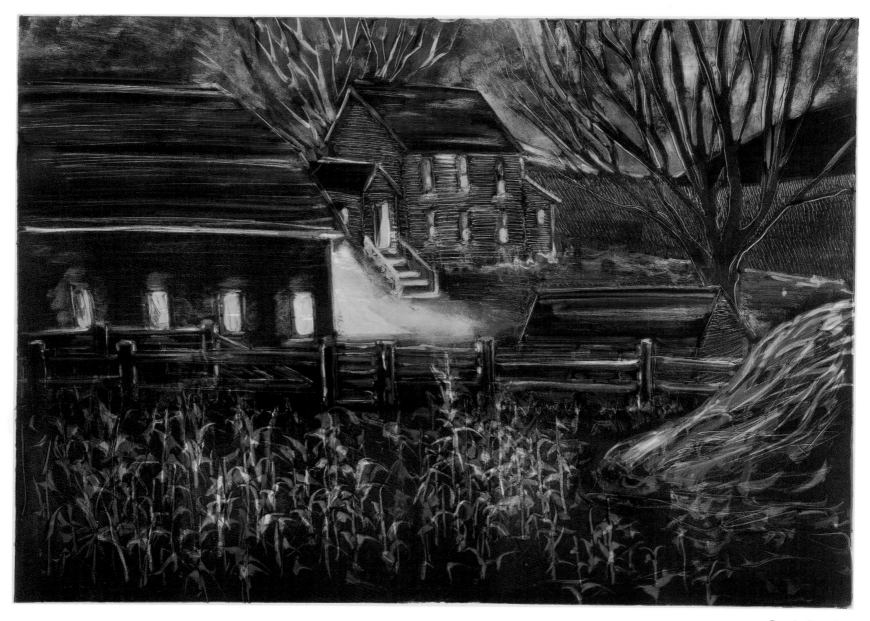

Day In Day Out
Nancy Arko

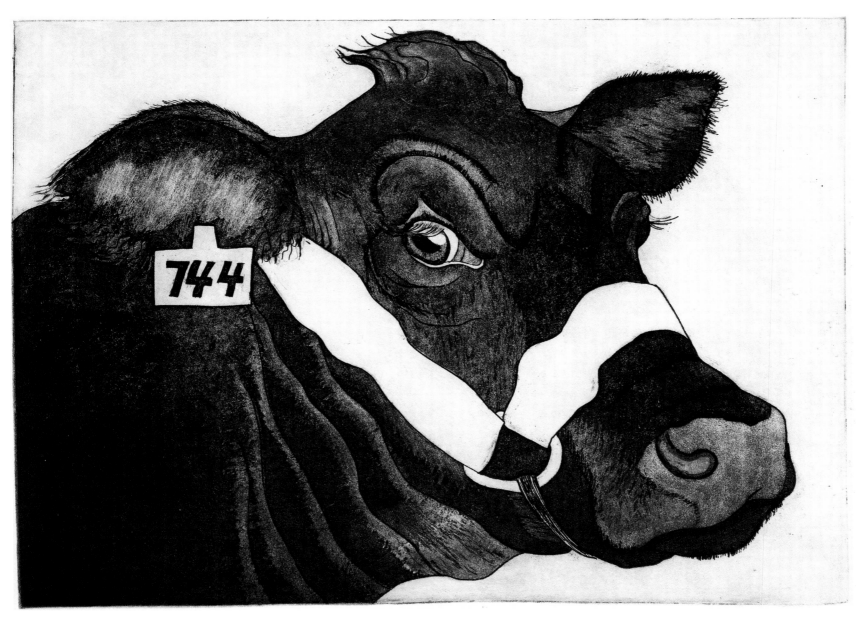

Angus 744
VacieAnna Berry

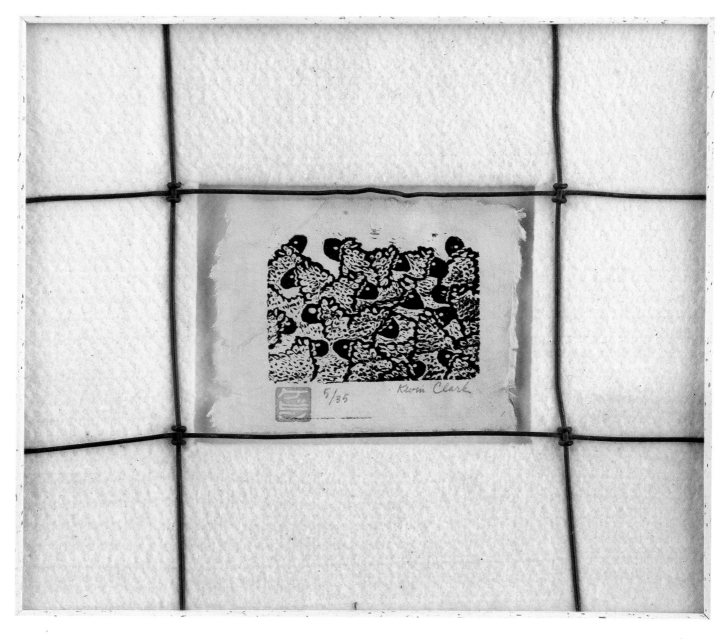

Sheep
Kevin Clark

Primrose Box
Gloria Cornelius

Powers That Be
Jonnel Covault

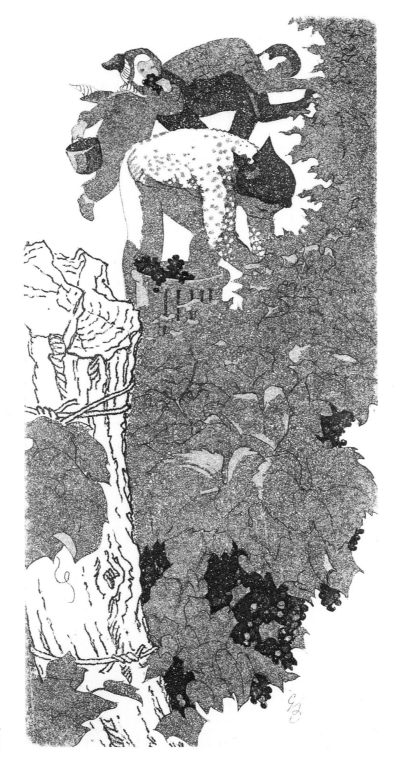

Grape Harvest
Carol Steichen Dumond

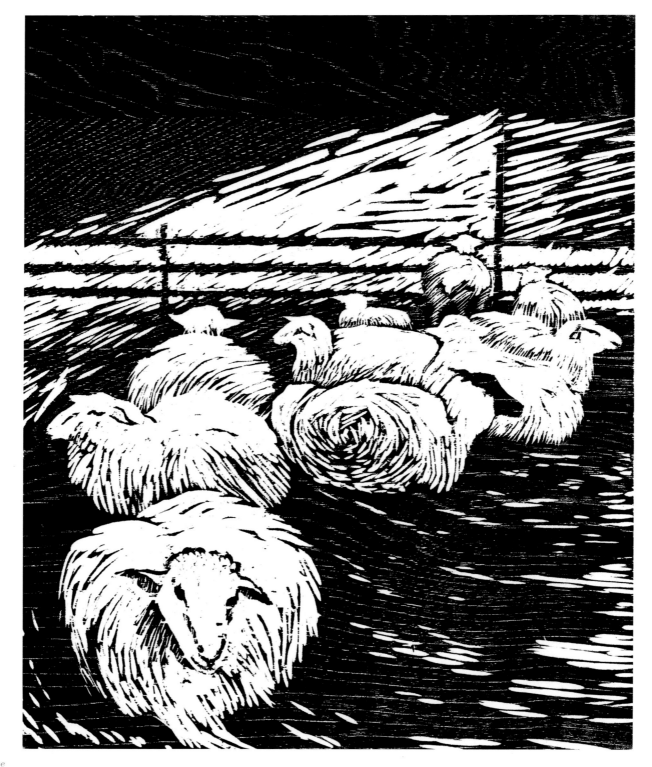

Ladies in Waiting
Lucia Durand

Watering Place
Paul Gentry

Willamette Country
Paul Gentry

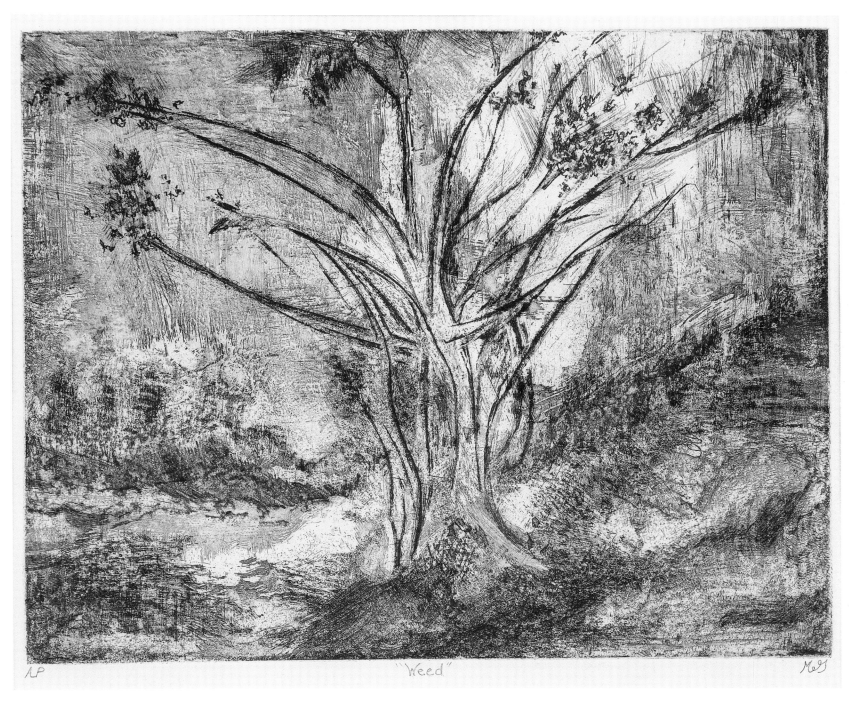

"Weed"

Weed
Margaret Graham

Growth Patterns
Margaret Graham

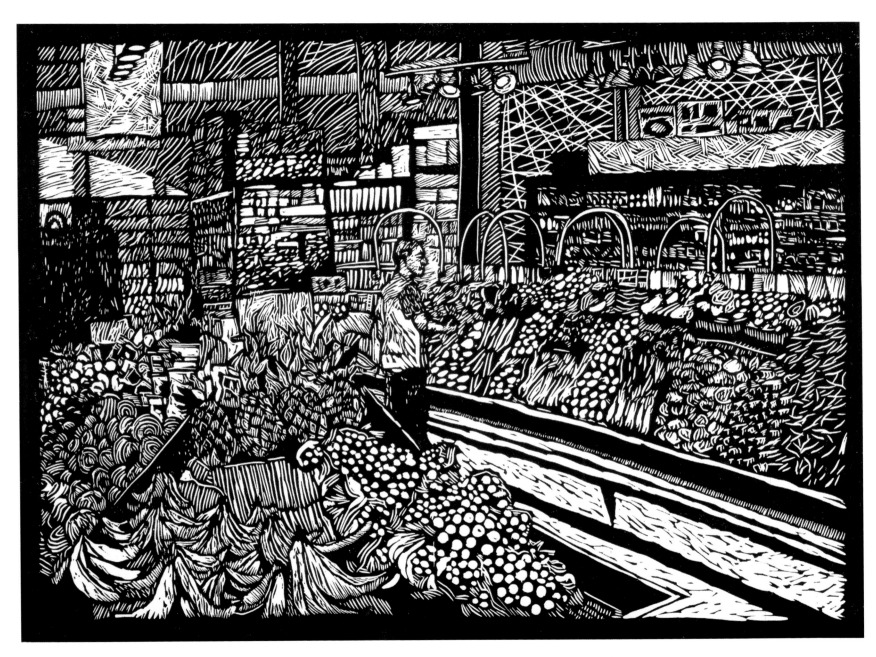

Produce
Miles Histand

Winter Wheat Fields
Michael Ireland

Esmeralda
Manuel Izquierdo

Edible Landscapes
Donna and Don Jepsen-Minyard

Amanita
Kristie Johnson

Cocoa de Mer-Seychelles
Nancy Kem

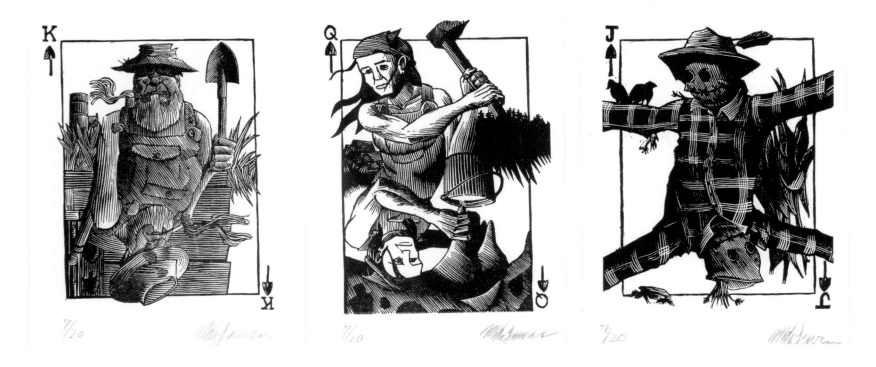

King, Queen, and Jack of Spades
Michael Lawrence

October Harvest
Connie Mueller

Colour Plate #10 Tulip Fields
Lyn and Stephen Nance-Sasser

Water Makes Trees
Margaret Prentice

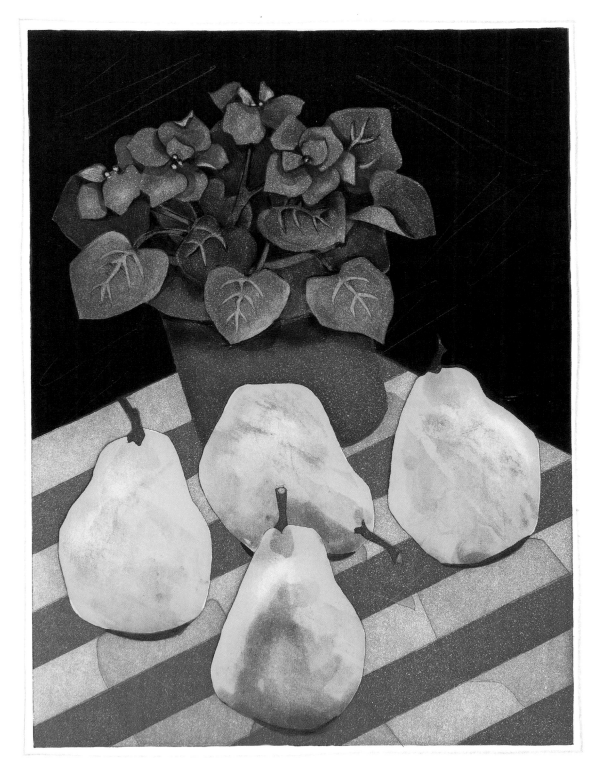

Violets and Pears
Carol Riley

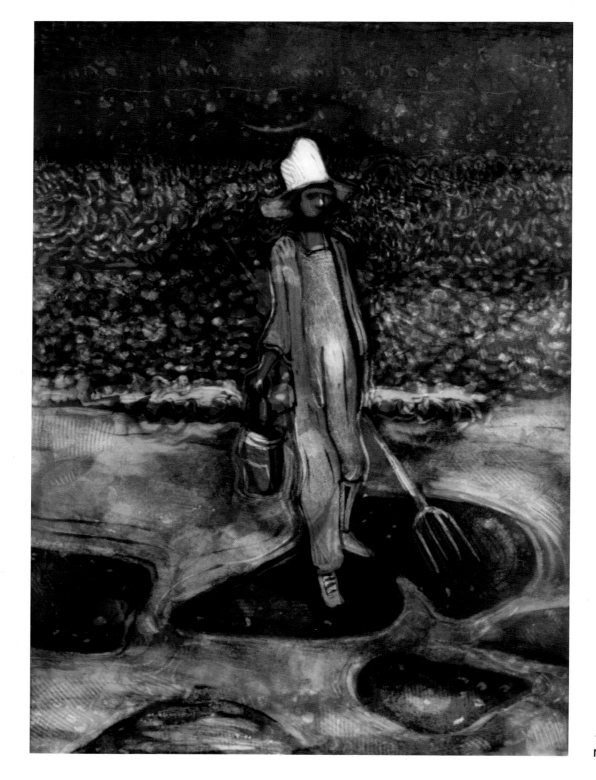

The Gardener
Nelson Sandgren

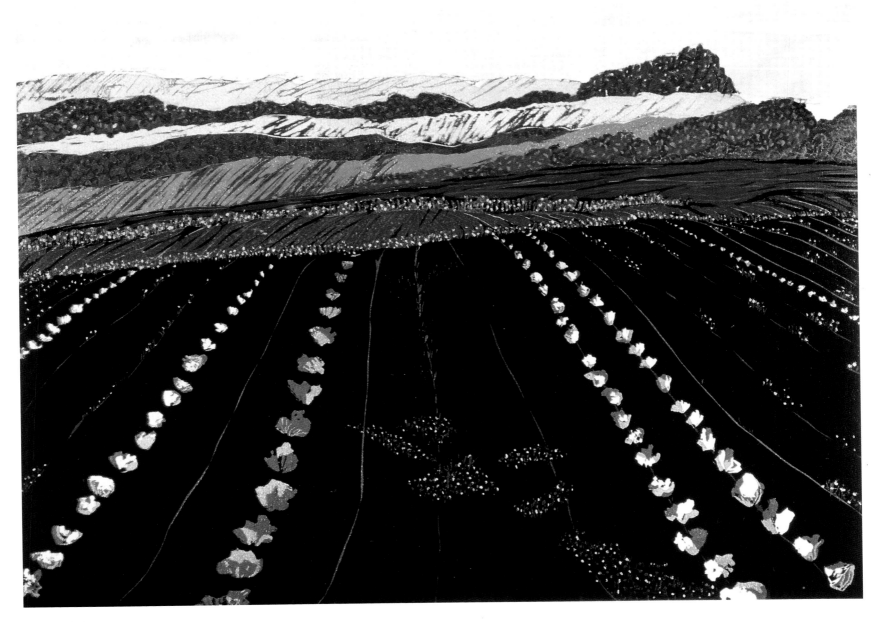

Peoria 8/10
Lauren Sauvage

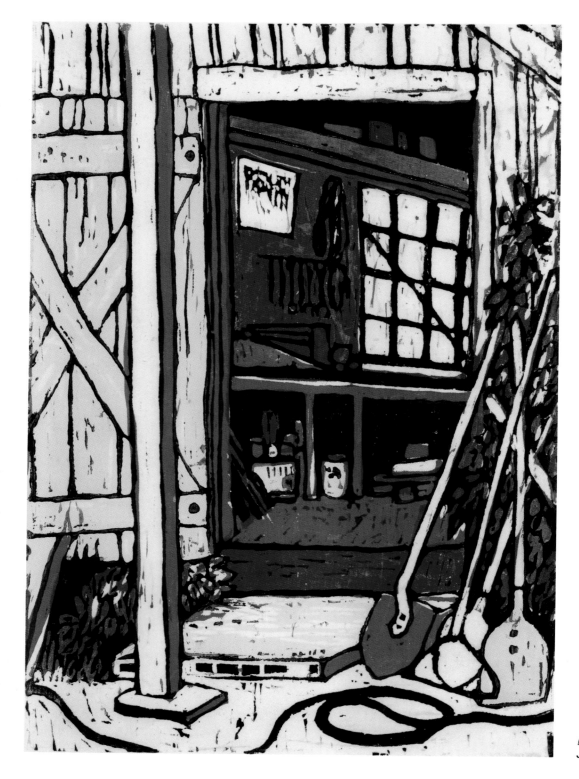

Bob's Bunkhouse
Jennifer Smith

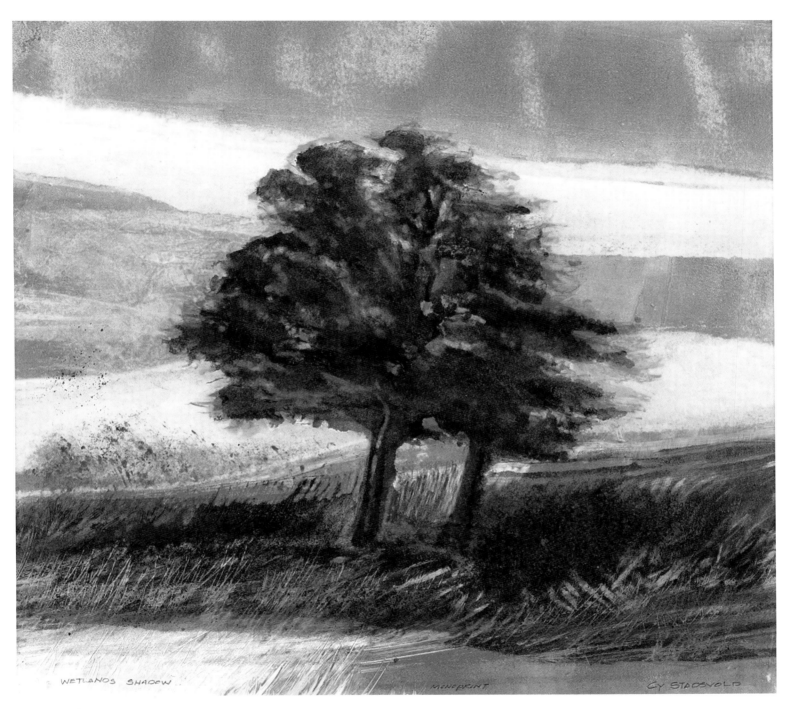

Wetlands Shadows
Cy Stadsvold

Turquoise Stove and Bread Rising Pan
Janna Beth Vaughn

Homage to Passages
Lynn Wiley

Wild Rose
Carol Yates

Blue Plate Special II
Renée Zangara

Bowl of Spring
Sandra S. Zimmer

Jam Session
Ken McCormack

Silo Shadow
Philip V. Augustin

Subject for a Gray Day
Cleve Bachelder

untitled
Mark Barnes

Boston Mill, Shedd, OR
Rich Bergeman

Karoo Door
Frank Biggs

Near Wilder, Jan. 1992
Jan Boles

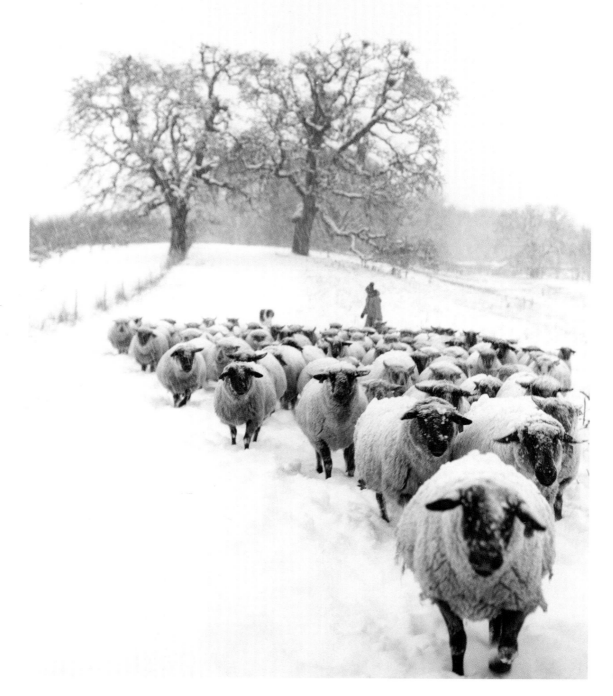

Snow and Sheep
David Buchanan

untitled
Larry Campbell

Crimson Clover
Marti Cheek

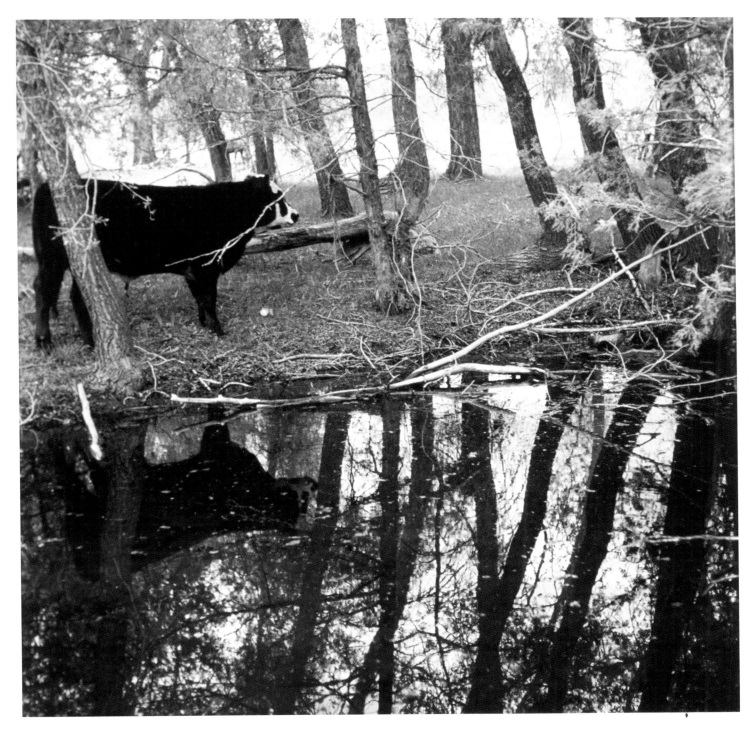

Two Bulls of Chama, New Mexico
Elaine Ellmaker Clark

Two Clovers
Elaine Ellmaker Clark

Catkins
Gordon K. Clark

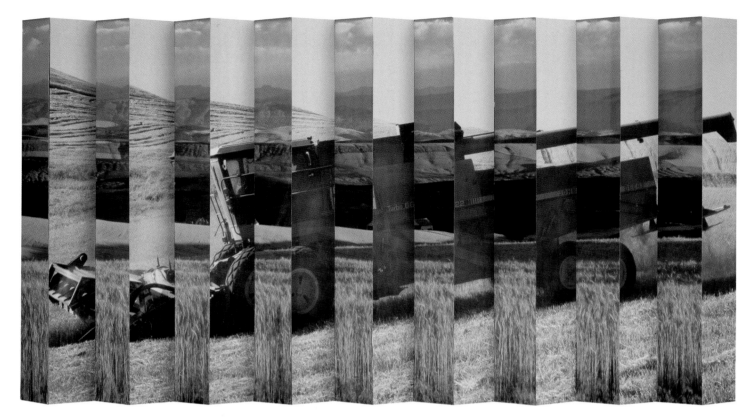

Harvest Synergy
(front, left, and
right views)
Gary Fields

Grain Silo, Eureka, Washington
Nancy Hagood

Massey-Ferguson
Christopher Irving

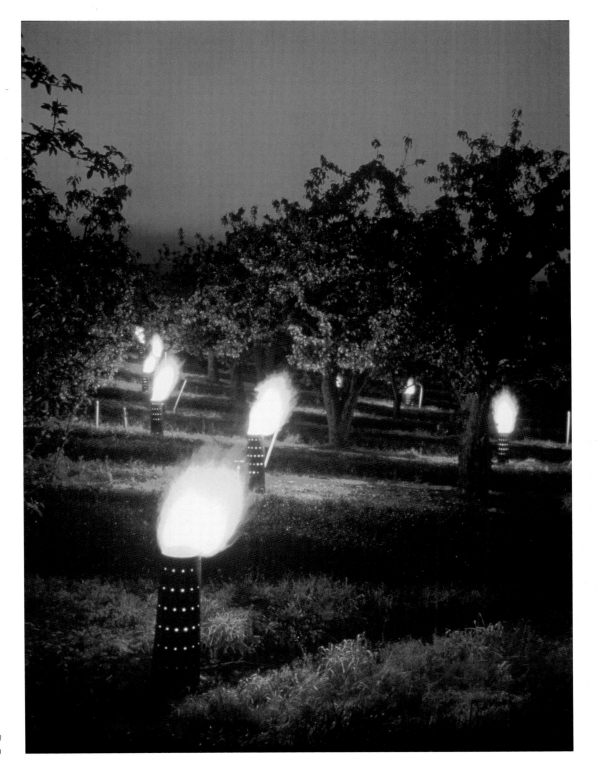

Nightwatch
Peter Marbach

Zinfandel Crush
Peter Marbach

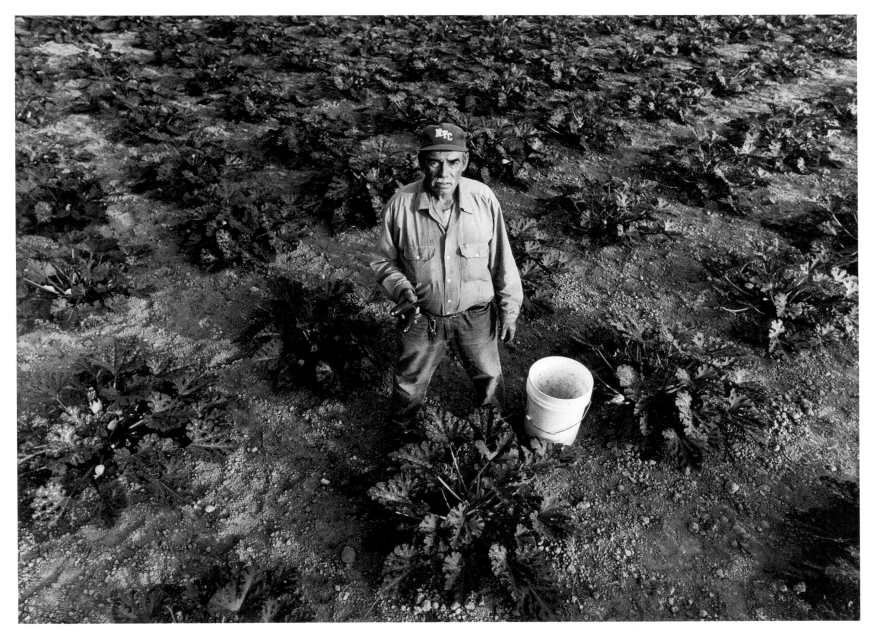

Tony Angelo in His Zucchini Field
Alan Mevis

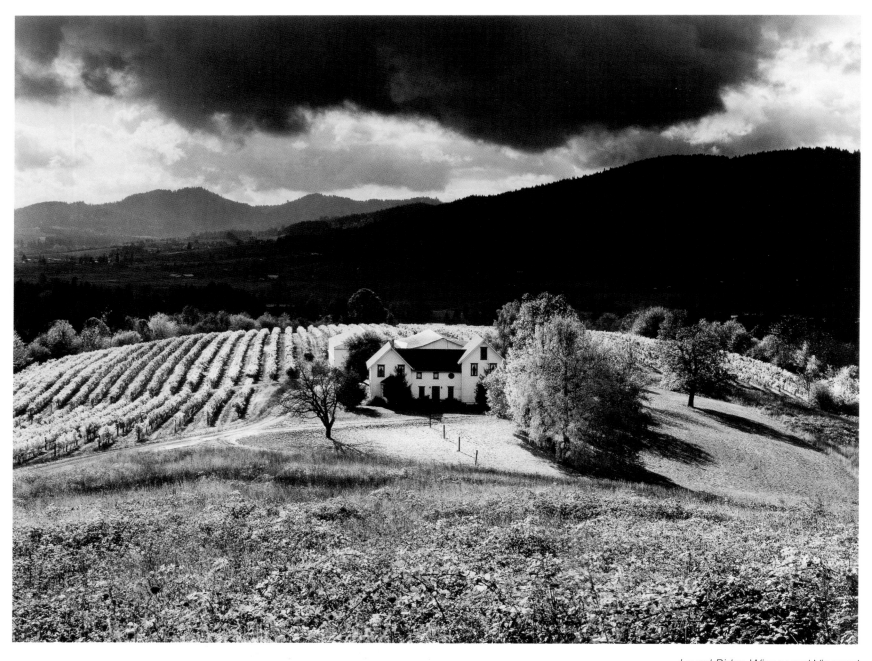

Laurel Ridge Winery and Vineyard
Loren Nelson

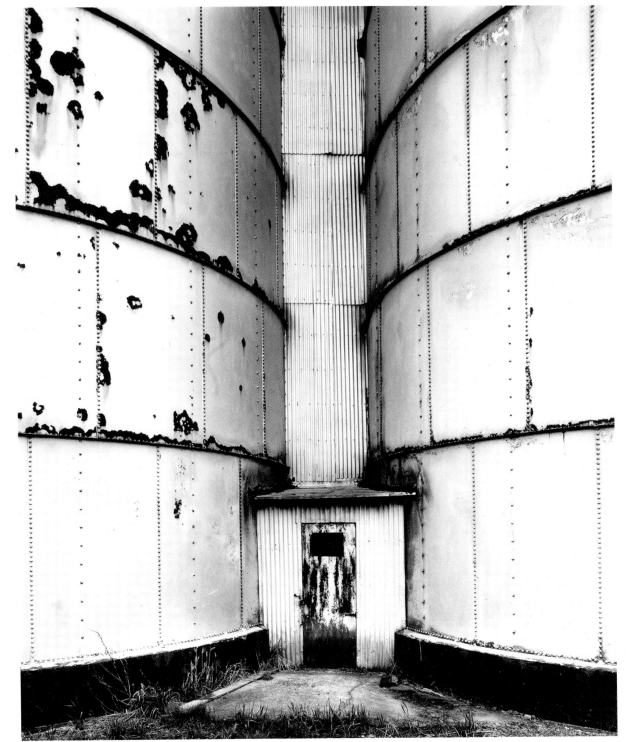

*Silos, Meeker Seed
with Grain; Amity, OR*
Loren Nelson

untitled
Alfred Owczarzak

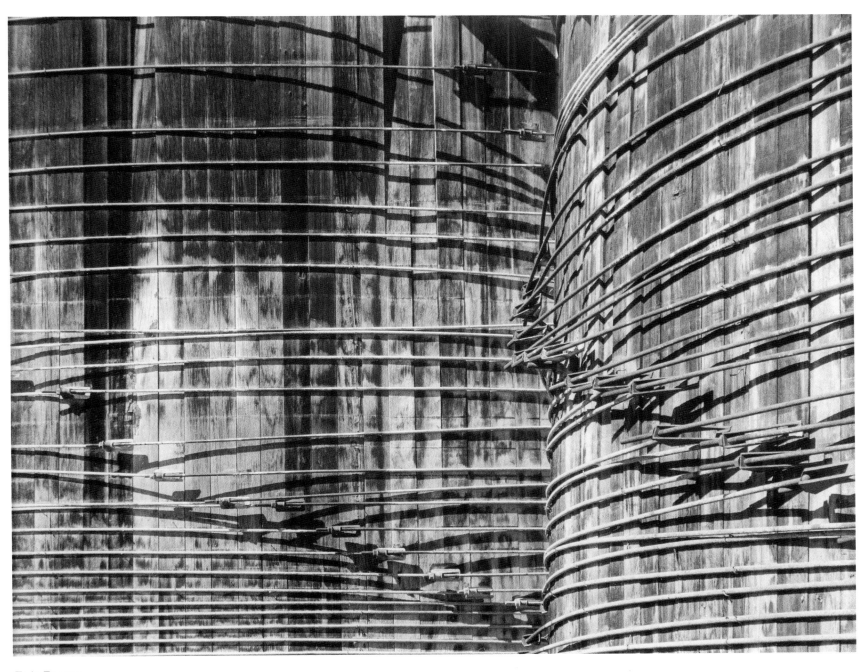

Twin Towers
Todd Parker

Swirled Tracks
Nancy Peterfreund

Cherry Boxes
Nancy Peterfreund

Romanian Sheep
Connie Petty

Jerseys
Bob Pool

Helix Wheatland
Bob Pool

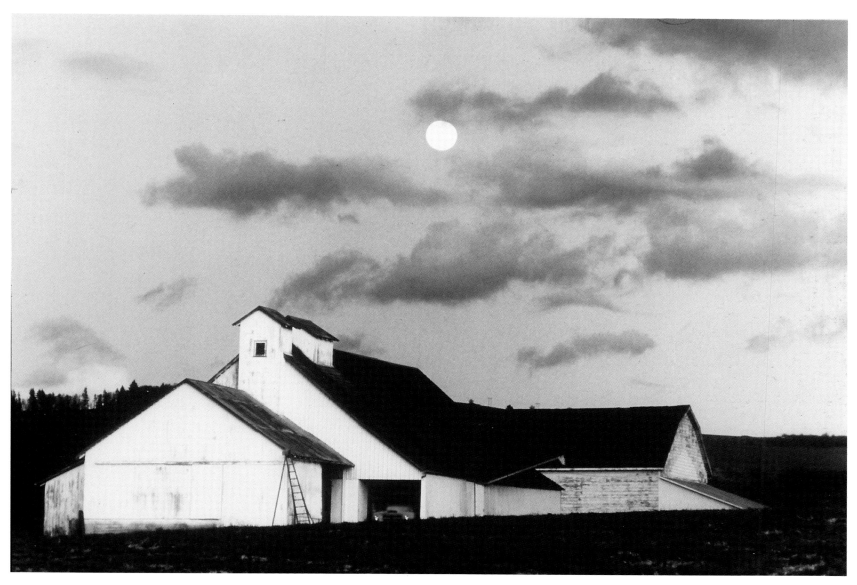

Polk County Moonrise
Bob Pool

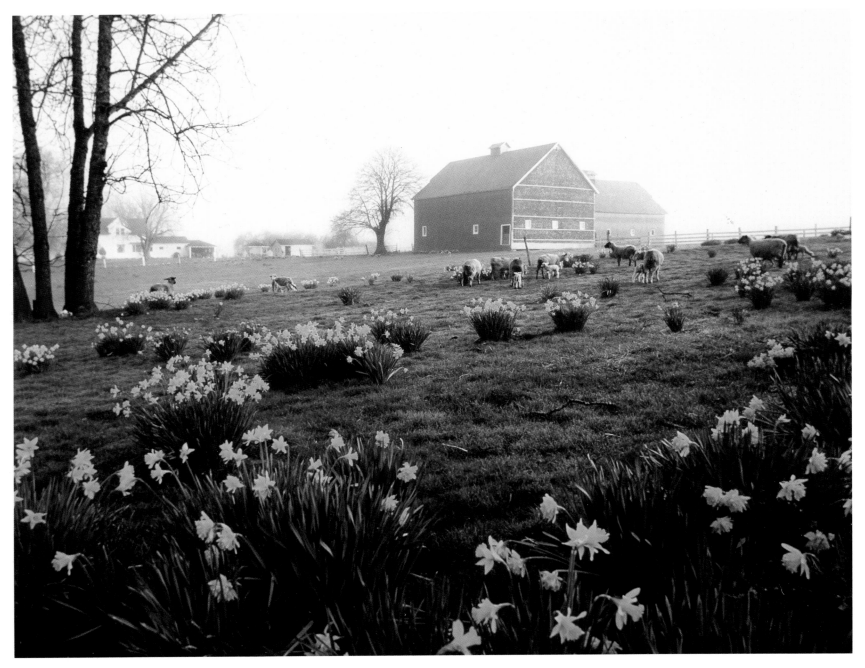

Daffodil Pasture
Bob Pool

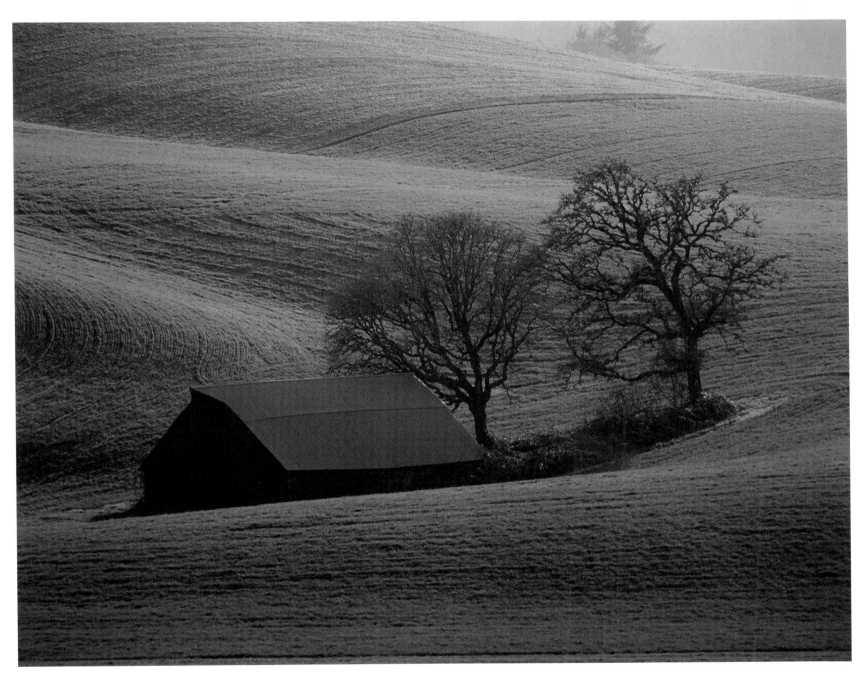

Green Fields of Home
Bob Pool

Patterns
Victor Saltveit

Alliumphobia
Susan Seubert

Duck Harvest
Marly Stone

Wheat Field, Burgundy
Gary Tepfer

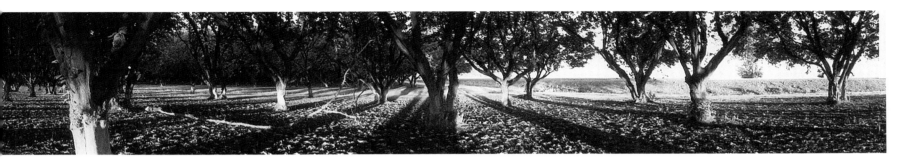

Filbert Orchard at Sunrise
Charles True

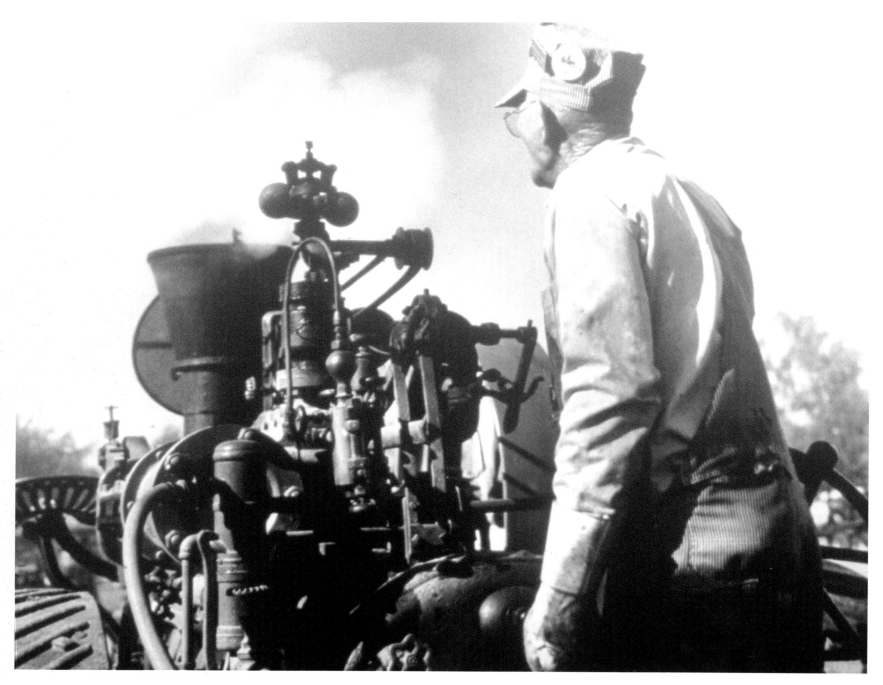

Forward to the Past
Don Whitaker

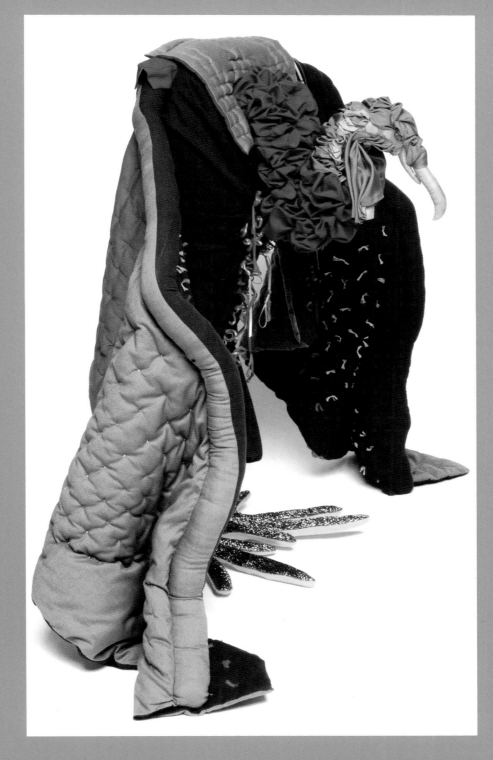

The Eternal Watch
Mary "Molly" Murphy

Fiber

Oregon Barns Summer and Winter
Patty Bentley

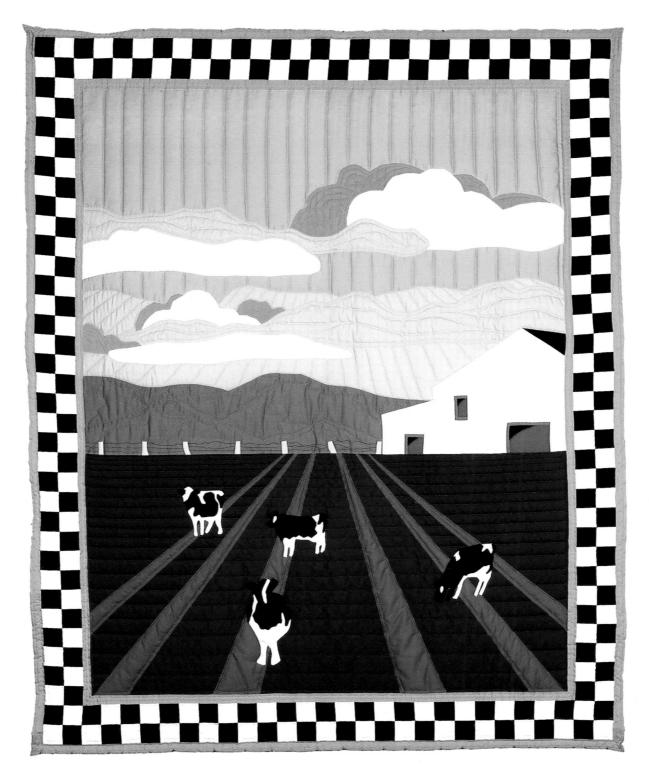

Morning
Janet Erickson

In the Valley
Marg Johansen

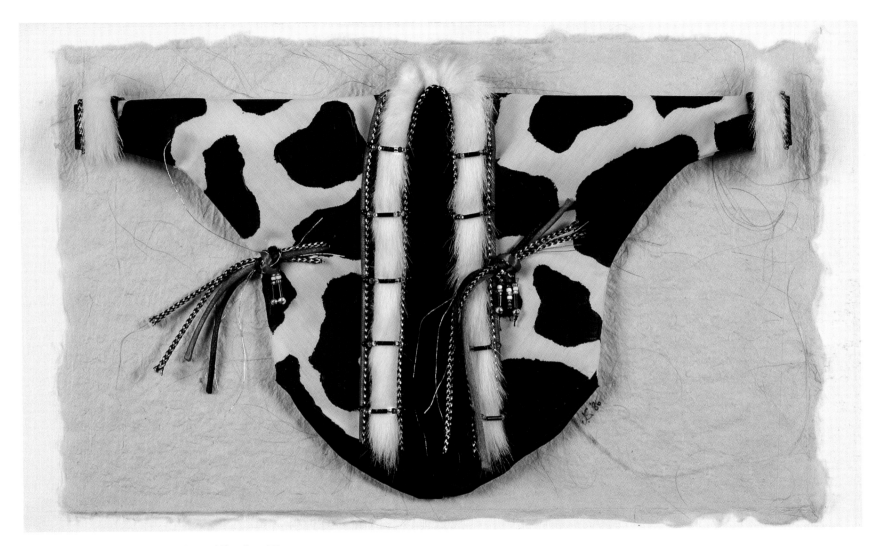

Bovine Dinner Jacket for the Annual Feed and Dance
Judith Sander

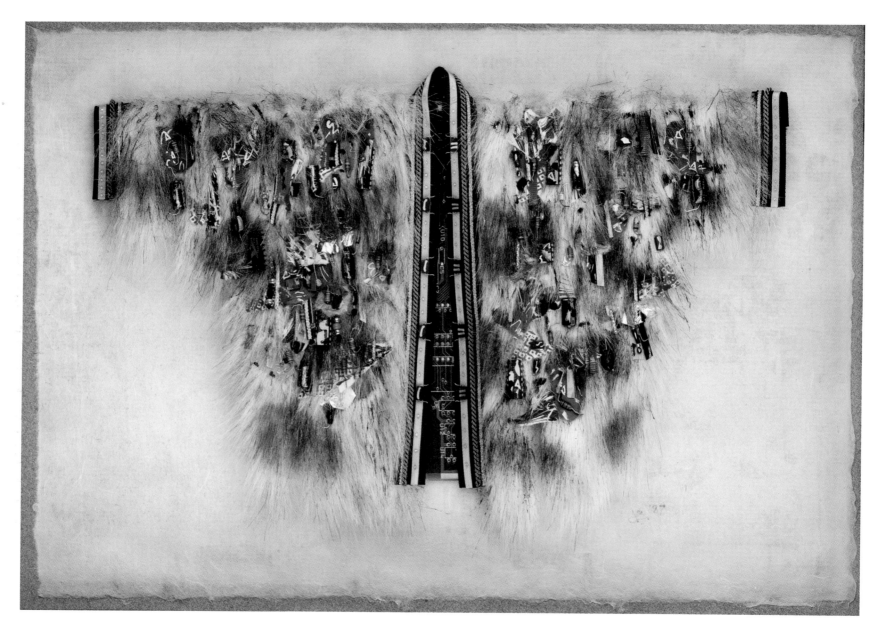

Clara Bell's Cow Chip Coat
Judith Sander

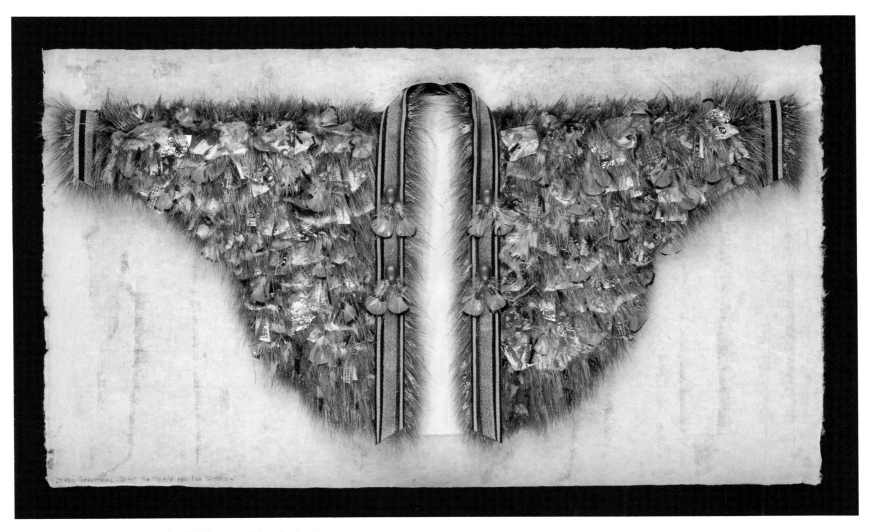

Zeke's Ceremonial Jacket for Chicken and Egg Gathering
Judith Sander

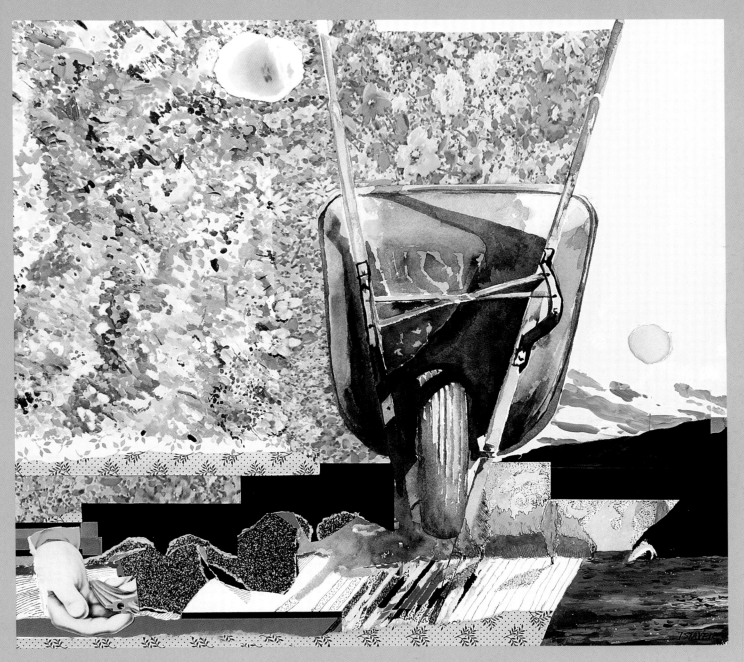

Boys, My Money's All Gone
Janice Staver

Sweet Betsy Romance
Clint Brown

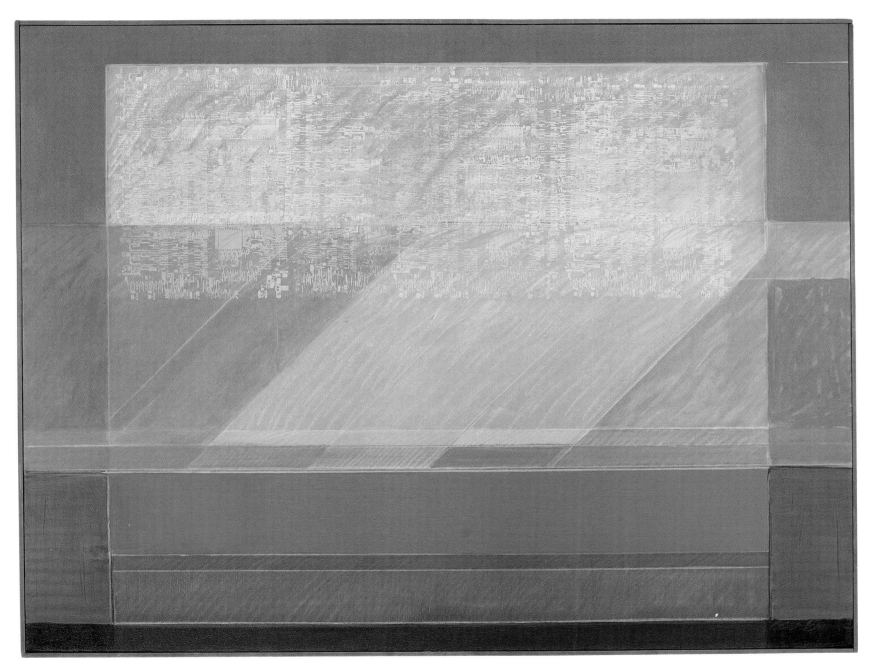

Winter Grass
Clint Brown

Spirit Ewe
Carol Chapel

Windbreak
JoAnn Gilles

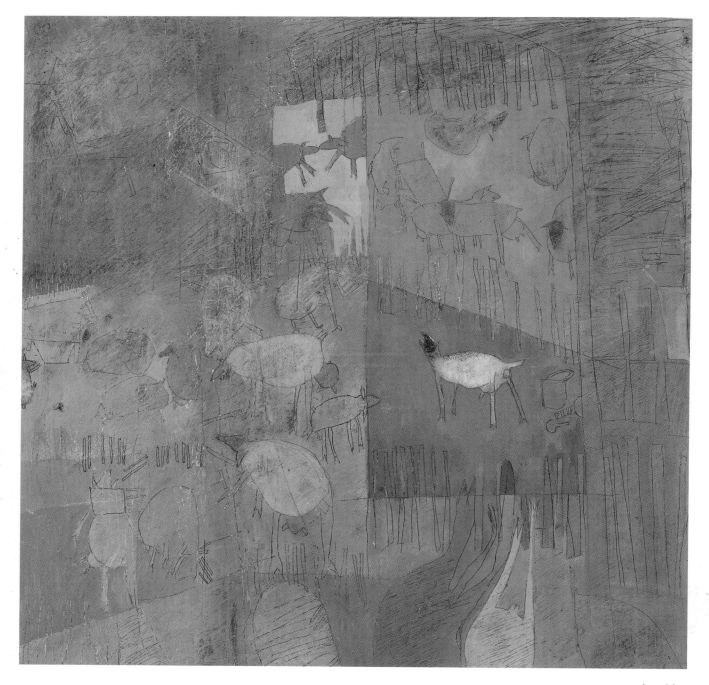

Lambing
Terry Gloeckler

Bessie, Bossie, Flo, and a Friend
Wendy Huhn

The Tree Farm
Gan E. Martin

Barn Swallows
Gan E. Martin

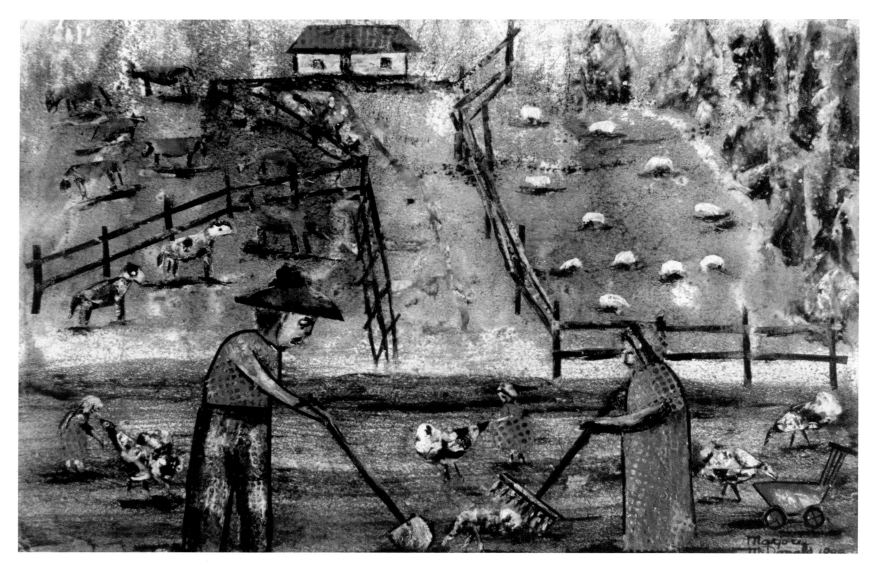

The Family Farm
Marjorie McDonald

An Apprehensive Bird
Marjorie McDonald

Fancy Feathers
Nancy McMorris

Farming in 1986
Robert S. Purser

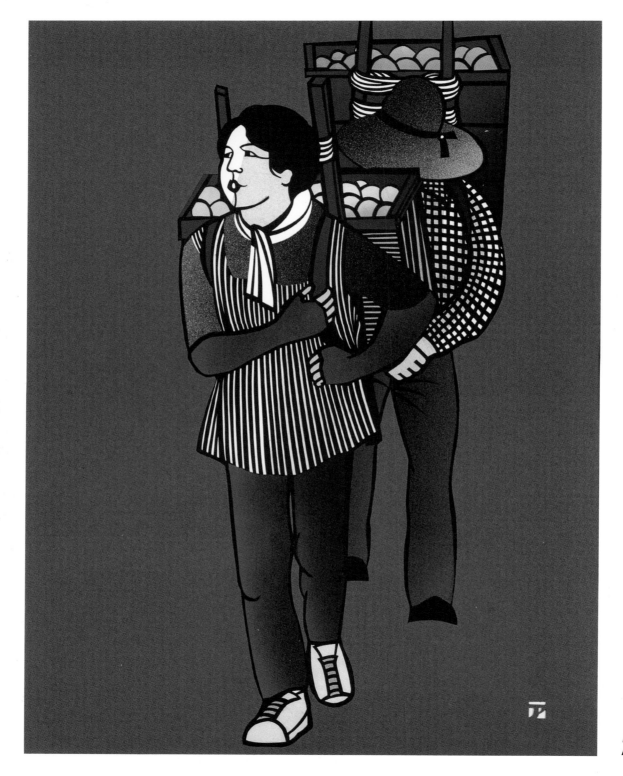

Homeward
Aki Sogabe

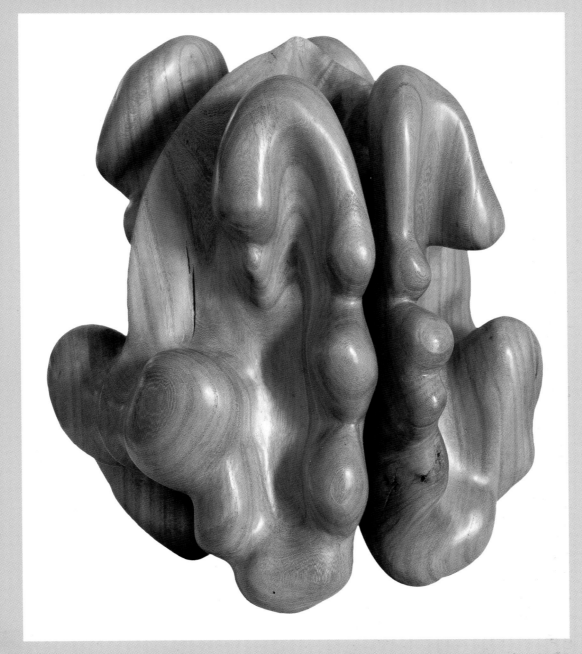

Walnut
Mark Elliot

Sculpture

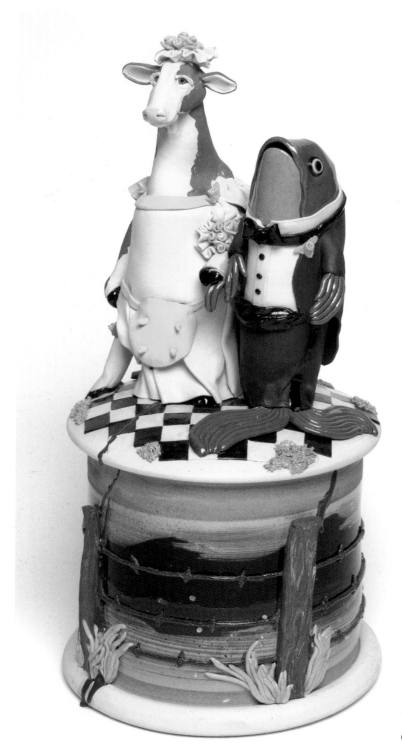

Salmoneo and Mooliet,
War on the Range
Claire Barr-Wilson

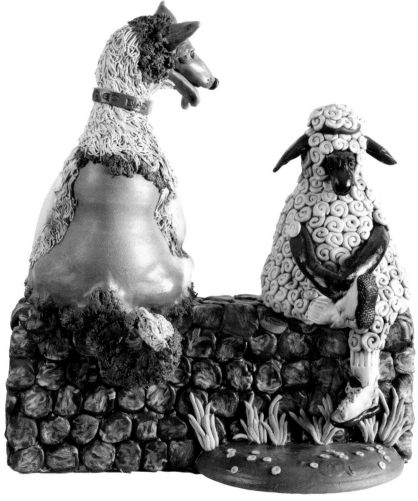

Dog with Intent
(front and back views)
Claire Barr-Wilson

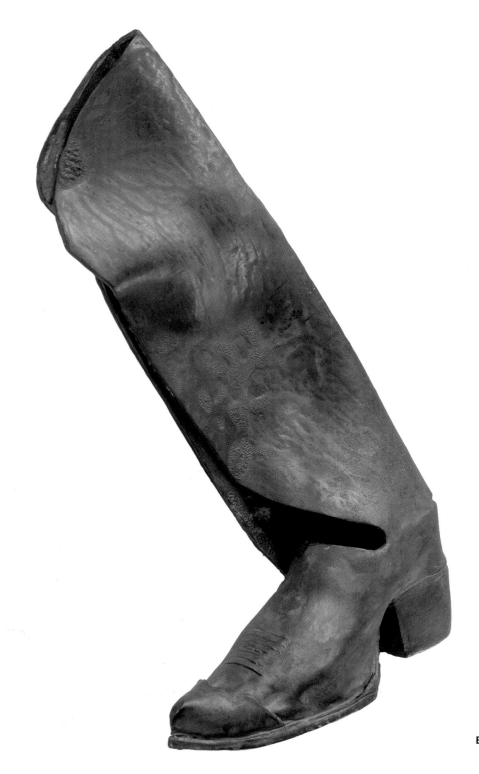

Farmhand
Barbara Anderson Bond

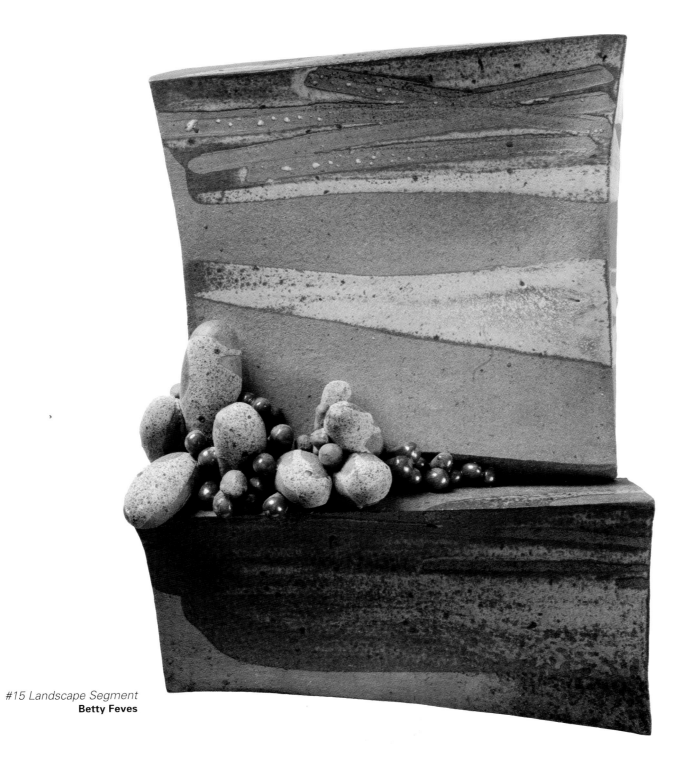

#15 Landscape Segment
Betty Feves

Where's the Bucket
Carol J. Krakauer

Tradition in Flight I
Doris Frischknecht Opager

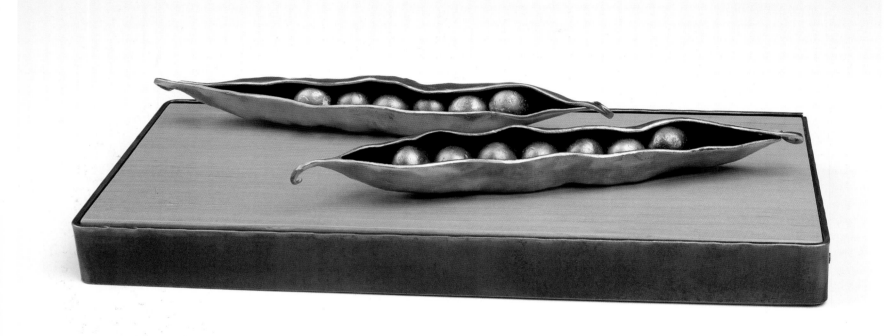

Pea Pods
Karen Rudd

Plow Bottom
Jason Saunders

Posters

ART ABOUT AGRICULTURE
OREGON STATE UNIVERSITY
COLLEGE OF AGRICULTURAL SCIENCES 1997

Posters from 1983, 1984, 1985 (Tom Weeks); previous page: 1997 (Tom Weeks)

Annual posters are the College's primary marketing tool for informing the public of the Art About Agriculture program's goals, accomplishments, and yearly competition. Posters from the first fourteen years attracted a loyal following for the program and for Tom Weeks' vogue graphic designs. As a matter of fact, Weeks appears in the 1995 poster in his straw hat painting a large blossom *en plein aire*. Weeks, a graphic designer in the Department of Extension and Experiment Station Communications, was first enlisted to create an illustration and layout for the program's inaugural art competition. As the story is remembered, an eleventh-hour announcement in the fall of 1982 arrived that all

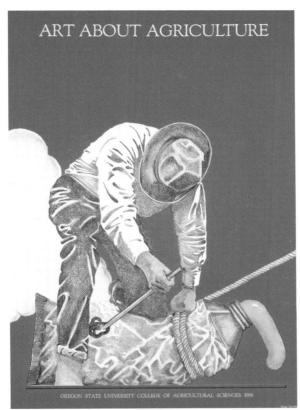

ART ABOUT AGRICULTURE

OREGON STATE UNIVERSITY COLLEGE OF AGRICULTURAL SCIENCES 1988

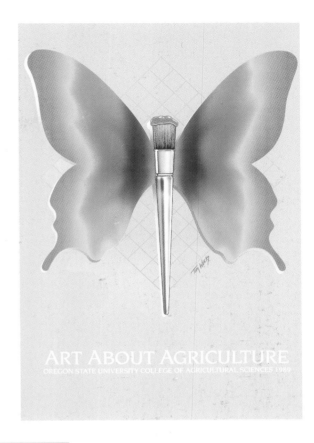

ART ABOUT AGRICULTURE

OREGON STATE UNIVERSITY COLLEGE OF AGRICULTURAL SCIENCES 1989

Posters from 1986, 1987 (below right), 1988, 1989 (Tom Weeks)

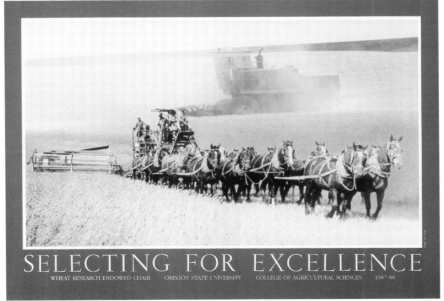

SELECTING FOR EXCELLENCE

WHEAT RESEARCH ENDOWED CHAIR OREGON STATE UNIVERSITY COLLEGE OF AGRICULTURAL SCIENCES 1987-88

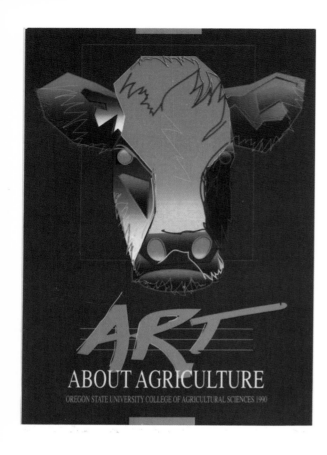

Posters from
1990, 1991, 1992
(Tom Weeks)

was in place to launch the program's first call to artists. Weeks and others in his department worked late into the night preparing the resulting elegant broadside, which served as a model for the program's subsequent annual posters.

To solicit submissions for the annual juried exhibit, a prospectus with a design similar to the year's poster is mailed directly to artists listed with the OSU Foundation in connection with Art About Agriculture, to the Oregon Arts Commission, to the Regional Arts and Culture Council of Portland, and to many other OSU alumni and friends. In 2005 the College also released news of the competition via the Internet. Additionally, the posters published in 2005 and 2006 highlighted the year's touring exhibition, with dates and locations printed on one side.

*Posters from
1993, 1994, 1995
(Tom Weeks)*

In 1996 an advisory review committee for the program recommended that the College begin featuring art from the Art About Agriculture Permanent Collection on the poster. They advised this change as a means to reinforce that the annual competitions seek fine art and to enlighten the public about the permanent art collection. Posters featuring art from the juried permanent collection began in 1998 with *Color Plate #10 Tulip Field*, a silkscreen print by Lyn and Stephen Nance-Sasser chosen for that anniversary poster.

The annual posters remain popular with collectors. Students new to Oregon State University, who often request one or more for their living spaces, count the posters among the first works of art they own. The posters included in this section of the catalog are displayed concurrently in the Oregon Historical Society as part of the retrospective exhibition.

*Posters from 1996
(Tom Weeks);
1998 (below left),
1999, 2000 (Amy
Charron)*

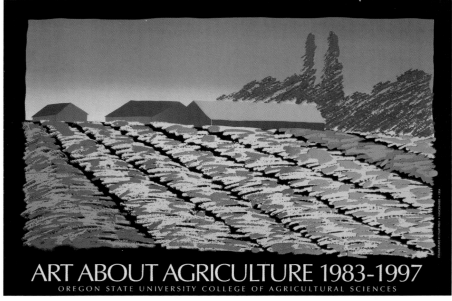

*Posters from 2001
(Tina Chovanec);
2002, 2003, 2004
(below right)
(Stephen Chovanec)*

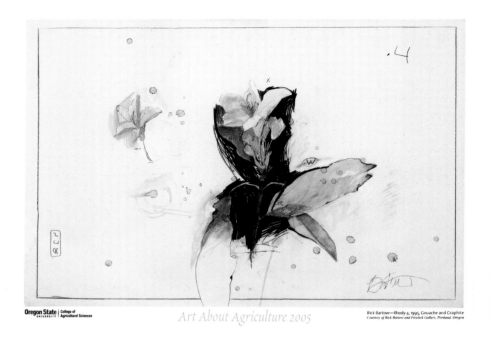

Art About Agriculture 2005

Rick Bartow—Rhody 4, 1995, Gouache and Graphite
Courtesy of Rick Bartow and Froelick Gallery, Portland, Oregon

*Posters from
2005, 2006
(Monica Whipple)*

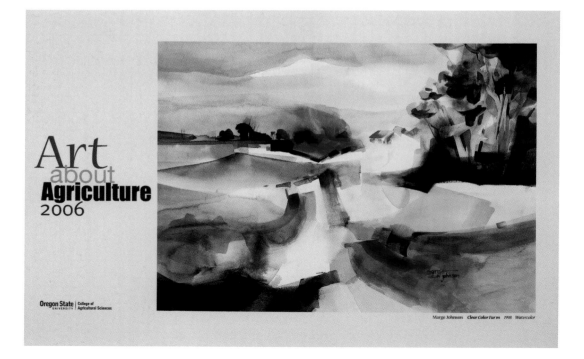

Margie Johnson Clear Color Farm 1998 Watercolor

Appendix I: Jurors

College of Agricultural Sciences former Artist in Residence

Tom Allen

Faculty, Oregon State University Department of Art

Harrison Branch

Clint Brown

Berkley Chappell

David Hardesty

Shelley Jordan

John Maul

John Rock (1919–1993)

Nelson Sandgren

Martha Wehrle

Phyllis Yes

Art faculty from other higher education institutions

Tallmadge Doyle, University of Oregon

James Kirk, Western Oregon University

Phyllis Yes, Lewis and Clark College
(formerly of OSU)

Artists who are not members of art department faculty

Humberto Gonzalez

Bonnie Hall (1931–2004)

Ronna Neuenschwander

Tad Savinar

Conrad J. Weiser

Arts advocates, gallery and museum affiliates

Jay Clemens

John Olbrantz

Sue Lynn Thomas

Agriculturists and related professionals

Maxine Hotchkiss

Sherry Kaseberg

Myla Keller

Carol Marx

Linda Patterson

Teresa Southworth

Virginia Tubbs

Appendix II: Exhibit History

Ashland, Ashland High School: 1986, 1988, 1996
Astoria, Astoria Community College: 1988
Baker, Crossroads Gallery: 1984, 1987, 1999
Bend, Central Oregon Community College: 1984
Bend, High Desert Museum: 2002
Bend, OSU Central Oregon: 2000
Bend, Sunbird Art Gallery: 1992
Burns, US Bank: 1998
Condon, Co-Arts: 1994, 2000
Coos Bay, Coos Art Gallery: 1989, 1996
Corvallis, Giustina Art Gallery: 1983–2001,
 2003–2006
Corvallis, OSU Memorial Union Concourse:
 1996, 2002
Enterprise, The Bookloft-Skylight Gallery: 1991,
 1995
Eugene, Erb Memorial Union Gallery: 1991
Eugene, Jacobs Gallery: 2005
Forest Grove, Pacific University: 1984
Forest Grove, Valley Art: 1994
Grants Pass Museum of Art: 1983, 1985, 1988,
 2003
Hermiston Public Library: 1992
Hood River, Columbia Art Gallery: 1991, 1998, 2000
Klamath Falls, Government Center: 2002
La Grande, Eastern Oregon State College: 1983
Madras, Art Adventure Gallery: 1990, 1999, 2003
Medford, Rogue Gallery and Art Center: 2004
Newport, Nye Beach Interactive Gallery: 2001
Newport, Visual Arts Center: 1993
Ontario, OSU Extension Service Office: 1986, 1997
Oregon City, Carnegie Center: 1999, 2004

Oregon City, Pauling Gallery, Clackamas
 Community College: 1983
Pendleton Center for the Arts: 2004
Pendleton, Western Heritage Gallery: 1983, 1996
Philomath, Benton County Historical Society: 1998
Portland, Albers Mill Building: 1992
Portland, Interstate Firehouse Cultural Center: 2005
Portland, Oregon Historical Society: 2001, 2006
 Retrospective
Portland, OSU II: 1996
Portland, OSU Portland Center
 (Purchased art/student art): 1991
Portland, Washington County Museum: 1990
Portland, World Forestry Center: 1986
Roseburg, The Art Gallery: 1985, 1997
Roseburg, Umpqua Valley Arts Association,
 Gallery II: 1993
Salem, State Capitol Galleria: 1983, 1985–1999,
 2005 OSU day
Salem, Oregon State Fair: 1986, 1988-1998
Silverton, The Oregon Garden: 2003
Springfield, Springfield Museum: 1998
The Dalles, The Oregon Trail Art Gallery/The Dalles
 Art Center: 1986, 1990, 2004
Tillamook County Pioneer Museum: 2005
Tillamook County Creamery: 1989, 1995
Vancouver, B.C., Expo: 1986
Walla Walla, WA, Carnegie Art Center: 1983, 2000,
 2006
Wenatchee, WA, Gallery: 1985
Yakima, WA, Larson Gallery: 1983

Provenance

Jim Adams
Corvallis, Oregon
b. 1951, Santa Monica, California
Pegasus Gallery, Corvallis

Buford Sensed He was Losing Control of the Situation,
page 52
1986, Watercolor, 23" x 22"
1987 Capital Press Purchase Award, Dewey Rand

Elgin Just Loved Drivin' Them Cattle, page 88
1989, Drawing: Graphite, 18" x 23.25"
1990 ELANCO Purchase Award, Paul Berger

Mark Allison
Corvallis, Oregon
b. 1948, San Rafael, California
Pegasus Gallery, Corvallis

Virtual Wheat, page 22
1993, Painting: Acrylic, 28" x 22"
1994 Carey and Glen S. Strome Agricultural Art
 Memorial Purchase Award, Gayle Strome

Marge Anderson
Lebanon, Oregon
b. 1932, Portland, Oregon

An Apple a Day, page 53
1982, Watercolor, 15" x 11.75"
1983 Lamb Foundation Purchase Award

Nancy Arko
Portland, Oregon
b. 1938, Virginia, Minnesota
Waterstone Gallery, Portland

Day In Day Out, page 104
1987, Print: Monotype, 27.75" x 20.25"
1988 Paul Lamb and Reese Lamb Art About
 Agriculture Purchase Award, Lamb Foundation

Philip V. Augustin
Salem, Oregon
b. 1960, Hutchinson, Kansas

Silo Shadow, page 136
2002, Photograph: Gelatin Silver Print, 15" x 15"
2003 OSU President's Award, and Paul Lamb and
 Reese Lamb Art About Agriculture Purchase
 Awards, Tim and Karen White and Lamb
 Foundation

Cleve Bachelder
Portland, Oregon
b. 1950, Rumford, Maine

Subject for a Gray Day, page 137
1984, Photograph: Type C, 7" x 8.75"
1985 Lamb Foundation Purchase Award

Mark Barnes
Portland, Oregon
b. 1954, St. Louis, Missouri

Untitled, page 138
1996, Photograph: Gelatin Silver Print, 11" x 17"
1997 R-3 Engraving Purchase Award, Charlotte
 Fleming

Claire Barr-Wilson
Talent, Oregon
b. 1947, Los Angeles, California
Hanson Howard Gallery, Ashland

Salmoneo and Mooliet, War on the Range, page 196
1997, Sculpture: Ceramic, 22.5" x 11" x 11"
1998 Paul Lamb and Reese Lamb Art About
 Agriculture Purchase Award, Lamb Foundation

Dog with Intent, page 197
1998, Sculpture: Ceramic, 18" x 16" x 11"
1999 Paul Lamb and Reese Lamb Art About
 Agriculture Purchase Award, Lamb Foundation

Rick Bartow
South Beach, Oregon
b. 1946, Newport, Oregon
Courtesy Rick Bartow and Froelick Gallery, Portland

Rhody 4, page 89
1997, Drawing: Gouache and Graphite,
25.5" x 37.75"
2003 John Olbrantz Juror's Award, and Paul Lamb
and Reese Lamb Art About Agriculture Purchase
Awards, OSU College of Agricultural Sciences and
Lamb Foundation

Amy Beller
Eugene, Oregon
b. 1955, Los Angeles, California

The Red Bowl, page 23
2004, Painting: Oil on Canvas, 11" x 11"
2005 Paul Lamb and Reese Lamb Art About
Agriculture Purchase Award, Lamb Foundation

Harry Bennett
Astoria, Oregon
b. 1919, South Salem, New York
River Sea Gallery, Astoria

The Winged Seeds, page 24
1987, Painting: Oil on Canvas, 19" x 25.5"
1988 Carey and Glen S. Strome Agricultural Art
Memorial Purchase Award, Gayle Strome

Patty Bentley
Portland, Oregon
b. 1934, Cincinnati, Ohio
Portland Art Museum, Rental Sales Gallery, Portland

Oregon Barns Summer and Winter, page 174
1984, Fiber: Fabric Quilt, 52" x 48"
1985 Lamb Foundation Purchase Award

Rich Bergeman
Corvallis, Oregon
b. 1949, Fremont, Ohio
Pegasus Gallery, Corvallis
Earthworks Gallery, Yachats

Boston Mill, Shedd, OR, page 139
2002, Photograph: Platinum-Palladium Print,
8" x 10"
2003 Northwest Environmental Purchase Award, the
Curtis family

Mary Berry
Albany, Oregon
b. 1943, McMinnville, Oregon

Heidi and Friends, page 54
1998, Watercolor, 15" x 22"
1999 Architects Four LLC Purchase Award, Howard
Smith

VacieAnna Berry
Grants Pass, Oregon
b. 1949, Ballinger, Texas
Griffith Art Gallery, Saledo, Texas
Kelly's Gallery on Main, Joseph, Oregon
Langford Gallery, Grants Pass

Angus 744, page 105
Unlocated since 1998
1989, Print: Aquatint Intaglio, 12" x 15"
1990 Director, Oregon Agricultural Experiment
Station Purchase Award, Missy and Thayne Dutson

Frank Biggs
Elsah, Illinois
b. 1948, Graaff-Reinet, South Africa

Karoo Door, page 140
1984, Photograph: Gelatin Silver Print, 10.25" x
10.25"
1985 Lamb Foundation Purchase Award

Jan Boles
Caldwell, Idaho
b. 1941, Fulton, Missouri
Lorinda Knight Gallery, Spokane, Washington

Near Wilder, Jan. 1992, page 141
1996, Photograph: Gelatin Silver Print toned with
selenium, 5.25" x 42"
1997 Kaseberg Family Purchase Award, Larry and
Sherry Kaseberg

Barbara Anderson Bond
Corvallis, Oregon
b. 1945, Painesville, Ohio

Farmhand, page 198
1983, Sculpture: Ceramic, 7" x 24" x 14"
1984 Lamb Foundation Purchase Award

Clint Brown
Corvallis, Oregon
b. 1941, Sheboygan, Wisconsin
Opus6ix Gallery, Eugene, Oregon

Sweet Betsy Romance, page 182
1983, Mixed Media: Mixed Media on Paper,
32" x 24.25"
1984 Lamb Foundation Purchase Award

Winter Grass, page 183
1986, Mixed Media: Mixed Media on Canvas,
48" x 58"
1987 Paul Lamb and Reese Lamb Art About
Agriculture Purchase Award, Lamb Foundation

David Buchanan
Corvallis, Oregon
b. 1944, Corvallis, Oregon

Snow and Sheep, page 142
Unlocated since 1998
1990, Photograph: Gelatin Silver Print, 14" x 11"
1991 Director, Oregon Agricultural Experiment
Station Purchase Award, Missy and Thayne Dutson

Douglas Campbell
Portland, Oregon
b. 1946, Syracuse, New York
Blue Trout Gallery, Newberg

Harvest Weave, page 90
1989, Drawing: Ink, 27" x 18"
1990 Paul Lamb and Reese Lamb Art About
Agriculture Purchase Award, Lamb Foundation

Larry Campbell

Untitled, page 143
1993, Photograph: Type C, 20" x 24"
1994 Director, Oregon Agricultural Experiment
Station Purchase Award, Missy and Thayne Dutson

Claudia Cave
Corvallis, Oregon
b. 1951, Salem, Oregon

Palouse Wheat, page 91
1996, Drawing: Graphite, 10" x 17.75"
1997 Paul Lamb and Reese Lamb Art About
Agriculture Purchase Award, Lamb Foundation

Carol Chapel
Corvallis, Oregon
b. 1940, Indianapolis, Indiana
Pegasus Gallery, Corvallis

Spirit Ewe, page 184
1991, Mixed Media: Silkscreen and Graphite,
18.5" x 27"
1992 Paul Lamb and Reese Lamb Art About
Agriculture Purchase Award, Lamb Foundation

Berkley Chappell
Corvallis, Oregon
b. 1934, Pueblo, Colorado

Impending Summer Storm, Wheat Fields, page 25
1985, Painting: Oil on Canvas, 36" x 36"
1986 Lamb Foundation Purchase Award

Ian Colpitts
 Corvallis, Oregon
 b. 1940, London, England
 Portland Art Museum, Rental Sales Gallery, Portland

Crop Duster, page 56
 1986, Watercolor, 18.125" x 26.125"
 1987 Dean, OSU College of Liberal Arts Purchase
 Award, Bill Wilkins

Monroe, page 57
 1988, Watercolor, 22.5" x 30.5"
 1989 Oregon Arts Commission Purchase Award,
 Christine D'Arcy

Andrew Cook
 Portland, Oregon
 b. 1968, New York, New York

Cheshire, Oregon, page 29
 1990, Painting: Oil on Canvas, 24" x 36"
 1991 Monsanto Purchase Award, Darby Moeller

Gloria Cornelius
 Salem, Oregon
 b. 1938, Woodburn, Oregon

Primrose Box, page 107
 1983, Print: Intaglio, 12.5" x 12.5"
 1984 Lamb Foundation Purchase Award

Jonnel Covault
 Oak Grove, Oregon
 b. 1954, Inglewood, California
 Beppu/Wiarda Gallery, Portland

Powers That Be, page 108
 1999, Print: Linoleum Block Print, 20" x 28"
 2000 Dean and Director, College of Agricultural
 Sciences and Oregon Agricultural Experiment
 Station Purchase Award, Missy and Thayne Dutson

Susan Cowan
 Portland, Oregon
 b. 1953, Tacoma, Washington
 Artist's Gallery 21, Vancouver, Washington
 Earthworks Gallery, Yachats
 Portland Art Museum, Rental Sales Gallery, Portland

The Islanders, page 58
 1988, Watercolor, 20" x 29"
 1989 Capital Press Purchase Award, Dewey Rand

Chris Cummings
 Amity, Oregon
 b. 1948, Long Beach, California
 Wild Wings, Lake City, Minnesota

Getting an Early Start, page 92
 1984, Drawing: Pen and Ink, 10" x 12"
 1984 Lamb Foundation Purchase Award

Tallmadge Doyle
 Eugene, Oregon
 b. 1956, New York, New York
 Augen Gallery, Portland
 Davidson Contemporary, Seattle, Washington

Anatomy of a Honey Bee IV, page 103
 2000, Print: Etching, Woodcut, 30" x 22"
 2001 Paul Lamb and Reese Lamb Art About
 Agriculture Purchase Award, Lamb Foundation

Seed Pod II, page 30
 1992, Painting: Oil and Conti on Paper,
 29.75" x 22.5"
 1993 Director, Oregon Agricultural Experiment
 Station Purchase Award, Missy and Thayne Dutson

Assorted Buds, page 31
 1995, Painting: Oil on Paper, 22" x 30"
 1996 Director, Oregon Agricultural Experiment
 Station Purchase Award, Missy and Thayne Dutson

Carol Steichen Dumond
 Eugene, Oregon
 b. 1923, Oregon City, Oregon

Grape Harvest, page 109
 1990, Print: Aquatint Etching , 6.75" x 3.25"
 1991 Kaseberg Family Purchase Award, Larry and
 Sherry Kaseberg.

Lucia Durand
 Corvallis, Oregon
 b. 1932, Pasadena, California

Ladies in Waiting, page 110
 1987, Print: Woodblock, 15.75" x 12.5"
 1988 OSU President's Purchase Award, John and
 Shirley Byrne

Jeana Edelman
 Portland, Oregon
 b. 1959, Eugene, Oregon

Threshold, page 32
 2001, Painting: Wax Paint on Board, 24" x 12"
 2002 Paul Lamb and Reese Lamb Art About
 Agriculture Purchase Award, Lamb Foundation

Mark Elliot
 Maryland
 b. 1949, Dallas, Oregon

Walnut, page 195
 1982, Sculpture: Wood, 11" x 9" x 9"
 1983 Lamb Foundation Purchase Award

Janet Erickson
 Redmond, Oregon
 b. 1949, Hanover, Pennsylvania

Morning, page 175
 1987, Fiber: Fabric Quilt, 71" x 47"
 1988 Capital Press Purchase Award, Dewey Rand

Betty Feves
 Formerly of Pendleton, Oregon
 b. 1918, Pendleton, Oregon; d. 1985

#15 Landscape Segment, page 199
 1983, Sculpture: Ceramic, 26" x 18" x 8.5"
 1984 Lamb Foundation Purchase Award

Gary Fields
 Hood River, Oregon
 b. 1942, Valdez, Alaska
 Columbia Art Gallery, Hood River

Harvest Synergy, page 148
 1996, Photograph: Ilfochrome Prints, 14" x 25"
 1997 OSU President's Purchase Award, Les and Paul
 Risser

Judy Findley
 Corvallis, Oregon
 b. 1942, Norfolk, Nebraska

Bird's Eye View of Agriculture, page 59
 1993, Watercolor, 17" x 22"
 1994 Oregon Women for Agriculture Purchase Award

Chrissy Froese
 Amity, Oregon
 b. 1949, McMinnville, Oregon

Persevere, page 93
 1986, Drawing: Watercolor, Ink, and Pencil,
 25" x 15.5"
 1987 Dean, Graduate School, Master of Arts
 Purchase Award, Tom and Carolyn Maresh

Paul Gentry
 Independence, Oregon
 b. 1954, Decatur, Illinois
 Print Arts Northwest, Portland, Oregon

Watering Place, page 111
 2003, Print: Wood Engraving, 8" x 4.5"
 2004 Roy D. Nielsen Art About Agriculture Purchase
 Award, the Roy D. Nielsen family

Sally Haley
Portland, Oregon
b. 1908, Bridgeport, Connecticut
Laura Russo Gallery, Portland

Filberts, page 21
1982, Painting: Acrylic on Canvas, 46"x 45.5"
1983 E. R. Jackman Foundation

Priscilla Hanson
Portland, Oregon
b. 1945, Milwaukee, Wisconsin

Outside Sheridan, page 33
2003, Painting: Acrylic on Wood with Pencil, Tape,
and Transfer, 36" x 30"
2004 Carey and Glen S. Strome Agricultural Art
Memorial Purchase Award, Gayle Strome

Karen Hendricks
Eugene, Oregon
b. 1941, Portland, Oregon
Alder Gallery, Coburg

Last Summer's Poppies, page 63
2001, Watercolor, 7.5"x 11"
2002 Larry and Sherry Kaseberg Award, Larry and
Sherry Kaseberg

Miles Histand
Portland, Oregon
b. 1973, Fort Collins, Colorado

Produce, page 115
2002, Print: Linocut, 18"x24"
2003 Capital Press Purchase Award, Mike O'Brien

Kathryn Honey
Corvallis, Oregon
b. 1932, Portland, Oregon
Art in the Valley Gallery, Corvallis

Ripening Tomatoes, page 64
2000, Watercolor, 11" x 15"
2001 Capital Press Purchase Award, Mike Forrester

Wendy Huhn
Dexter, Oregon
b. 1953, Phoenix, Arizona
Jane Sauer's Thirteen Moons Gallery, Santa Fe, New
Mexico

Bessie, Bossie, Flo, and a Friend, page 187
1986, Mixed Media: Quilting, Plastic, Fabric, and
Paper, 35" x 43"
1987 Paul Lamb and Reese Lamb Art About
Agriculture Purchase Award, Lamb Foundation

Michael Ireland
Formerly of Portland, Oregon
b. 1953, New London, Connecticut; d. 2000

Winter Wheat Fields, page 116
1983, Print: Aquatint Etching , 7" x 7"
1984 Lamb Foundation Purchase Award

Christopher Irving
Silverton, Oregon
b. 1965, Corvallis, Oregon

Massey-Ferguson, page 150
1993, Photograph: Type C, 11" x 14"
1994 Dean, Graduate School, Master of Arts
Purchase Award, Tom and Carolyn Maresh

Manuel Izquierdo
Portland, Oregon
b. 1925, Madrid, Spain
Laura Russo Gallery, Portland

Esmeralda, page 117
1983, Print: Woodcut, 28" x 19"
1984 Lamb Foundation Purchase Award

Don Jepsen-Minyard
Corvallis, Oregon
b. 1956, Plainview, Texas

Edible Landscapes, page 118
1986, Print: Serigraph, 13" x 19"
1987 Paul Lamb and Reese Lamb Art About
Agriculture Purchase Award, Lamb Foundation

Donna Jepsen-Minyard
Corvallis, Oregon
b. 1958, Ankara, Turkey

Edible Landscapes, page 118
1986, Print: Serigraph, 13" x 19"
1987 Paul Lamb and Reese Lamb Art About
Agriculture Purchase Award, Lamb Foundation

Marg Johansen
Formerly of McMinnville, Oregon
b. 1923, Ottawa, Kansas; d. 2004

In the Valley, page 176
Unlocated since 1998
1982, Fiber: Tapestry Wool, 28" x 38"
1983 Lamb Foundation Purchase Award

Kristie Johnson
Eugene, Oregon
b. 1964, Ukiah, California

Amanita, page 119
2002, Print: Silkscreen, 25" x 17.75"
2003 Capital Press and Paul Lamb and Reese Lamb
Art About Agriculture Purchase Awards, Mike
O'Brian and Lamb Foundation

Marge Johnson
Tigard, Oregon
b. 1940, Pasadena, California

Clear Color Farm, page 65
1998, Watercolor, 22" x 30"
1999 Dean and Director, College of Agricultural
Sciences and Oregon Agricultural Experiment
Station Purchase Award, Missy and Thayne Dutson

Susan S. Johnson
Corvallis, Oregon
b. 1938, Newark, New Jersey

From "Flower" to Food, page 95
1999, Drawing: Oil Bar, 29.5" x 18.5"
2000 Jurors' Poster Purchase Award, OSU College of
Agricultural Sciences

Jennifer Joyce
Portland, Oregon
b. 1942, Nassau County, New York
Portland Art Museum, Rental Sales Gallery

Patchwork, page 66
1989, Watercolor, 24" x 18"
1990 Carey and Glen S. Strome Agricultural Art
Memorial Purchase Award, Gayle Strome

Southern Exposure, page 67
1992, Watercolor, 18" x 24"
1993 Dean, College of Agricultural Sciences
Purchase Award, Conrad and Deanie Weiser

Nancy Kem
Formerly of Astoria, Oregon
d. 1997

Cocoa de Mer-Seychelles, page 120
1993, Print: Woodcut, 24" x 18"
1994 OSU President's Purchase Award, John and
Shirley Byrne

Edwin Koch
Bend, Oregon
b. 1937, Missoula, Montana
Collectors' Corner, Philharmonic Center for the Arts,
Naples, Florida

Sheep Grazing Near Amity, page 34
1982, Painting: Oil on Canvas, 31.5" x 46.5"
1983 Lamb Foundation Purchase Award

Carol J. Krakauer
Corvallis, Oregon
b. 1927, Troy, New York

Where's the Bucket, page 200
1986, Sculpture: Fused Glass, 15" x 16.75"
1987 Paul Lamb and Reese Lamb Art About
Agriculture Purchase Award, Lamb Foundation

Tom Kramer
Sagle, Idaho
b. 1946, Portland, Oregon

Shepherd's Nightmare, page 96
1987, Drawing: Watercolor and Color Pencil,
12" x 12"
1989 Paul Lamb and Reese Lamb Art About
Agriculture Purchase Award, Lamb Foundation

Jan Kunz
Kentfield, California
b. 1922, Portland, Oregon

Wheel and Sprockets, page 68
1982, Watercolor, 20" x 24"
1983 Lamb Foundation Purchase Award

Michael Lawrence
Eugene, Oregon
b. 1980, Lancaster, California

King, Queen, and Jack of Spades, page 121
2002, Print: Wood Engraving, 4.5" x 14" triptych,
4.5" x 3" each
2003 University Honda Purchase Award, Ron Theis

Jean Lea
Gervais, Oregon
b. 1953, Salem, Oregon

Night Growth, page 69
1992, Watercolor, 22" x 30"
1993 Land O'Lakes Purchase Award, Bonnie
Neuenfeldt

Charles M. Leach
Corvallis, Oregon
b. 1924, Sacramento, California

Reflections on Time, page 35
2000, Painting: Acrylic on Canvas, 19.5" x 23.5"
2001 Roy D. Nielsen Art About Agriculture Purchase
Award, the Roy D. Nielsen family

Susan Lewis
Honolulu, Hawaii

Wet Green, page 97
1990, Drawing: Pastel, 20" x 26"
1991 Oregon Women for Agriculture Purchase Award

Doreen Lindstedt
Rockaway Beach, Oregon
b. 1931, Portland, Oregon
Portland Art Museum, Rental Sales Gallery

The Day Willow Met the Girls, page 70
1993, Watercolor, 13" x 18.5"
1994 Capital Press Purchase Award, Dewey Rand

Dyanne Locati
Gladstone, Oregon
b. 1942, Walla Walla, Washington
Portland Art Museum, Rental Sales Gallery

Tassels, page 98
1992, Drawing: Color Pencil, 20" x 24"
1993 Oregon Women for Agriculture Purchase Award

Peter Marbach
Hood River, Oregon
b. 1956, Ransomville, New York
Columbia Art Gallery, Hood River

Nightwatch, page 151
1996, Photograph: Type C, 24" x 20°"
1997 Dean and Director, College of Agricultural
Sciences and Oregon Agricultural Experiment
Station Purchase Award, Missy and Thayne Dutson

Zinfandel Crush, page 152
1998, Photograph: Type C, 20" x 24"
1999 Dean and Director, College of Agricultural
Sciences and Oregon Agricultural Experiment
Station Purchase Award, Missy and Thayne Dutson

Bill Marshall
Albany, Oregon
b. 1951, San Francisco, California

Blue Border, page 71
1988, Watercolor, 21″ x 29.75″
1989 E. R. Jackman Purchase Award, E. R. Jackman
Board of Directors, OSU Foundation

Gan E. Martin
Formerly of Coos Bay, Oregon
b. 1937, Buhl, Idaho; d. 2004

The Tree Farm, page 188
1992, Mixed Media, 24″ x 36″
1993 Paul Lamb and Reese Lamb Art About
Agriculture Purchase Award, Lamb Foundation

Barn Swallows, page 189
1993, Mixed Media, 24″ x 14″
1994 Dean, OSU College of Liberal Arts Purchase
Award, Bill Wilkins

Ken McCormack
Neskowin, Oregon
b. 1939, Shreveport, Louisiana

Jam Session, page 135
1991, Photograph: Type C, 11″ x 14″
1992 Oregon Women for Agriculture Purchase Award

Marjorie McDonald
Formerly of Corvallis, Oregon
b.1898, Buhl, Idaho; d.1995
Andrea Campbell, www.teleport.com/~lionne/
marjorie.htm

The Family Farm, page 190
1987, Mixed Media: Oil and Rice Paper Collage,
11″ x 17″
1988 Paul Lamb and Reese Lamb Art About
Agriculture Purchase Award, Lamb Foundation

An Apprehensive Bird, page 191
1988, Mixed Media: Oil and Rice Paper Collage,
13.75″ x 10″
1989 University Honda Purchase Award, Ron Theis

Nancy McMorris
Albany, Oregon
b. 1935, Denver, Colorado

The Ladies of Thistle Hill, Nos. 42, 65, 63, page 72
1990, Watercolor, 21″ x 28″
1991 C. L. Newman Company Purchase Award, Greg
Syverson

Fancy Feathers, page 192
1998, Mixed Media, 20″ x 29″
1999 Oregon Women for Agriculture Purchase Award

Alan Mevis
Portland, Oregon
b. 1946, Detroit, Michigan

Tony Angelo in His Zucchini Field, page 153
2003, Photograph: Gelatin Silver Print, 11″ x 14″
2004 Jim and Stella Coakley Purchase Award, Jim
and Stella Coakley

Clarice Miller
Yacolt, Washington
b. 1924, Mount Vernon, Washington

Showtime for Pot Belly, page 73
1991, Watercolor, 13.5″ x 20″
1992 Dean, Graduate School, Master of Arts
Purchase Award, Tom and Carolyn Maresh

Connie Mueller
Eugene, Oregon
b. 1944, Hollywood, California
White Lotus Gallery, Eugene

October Harvest, page 122
2002, Print: Lino-Reduction, 12″ x 18″
2003 OSU Extension Directors' Purchase Award, Lyla
and Mike Houglum, Debbie and Bill Maddy, and
John and Patty Winder

Mary "Molly" Murphy
Mollala, Oregon
b. 1952, San Francisco, California

The Eternal Watch, page 173
1982, Fiber: Soft Sculpture, 28" x 30" x 10"
1983 Lamb Foundation Purchase Award

Lyn Nance-Sasser
Portland, Oregon
b. 1947, Portland, Oregon
Portland Art Museum Rental Sales Gallery, Portland

Colour Plate #10 Tulip Fields, page 123
1984, Print: Serigraph, 16.5" x 27.5"
1985 Lamb Foundation Purchase Award

Stephen Nance-Sasser
Portland Oregon
b. 1946, Portland, Oregon
Portland Art Museum Rental Sales Gallery

Colour Plate #10 Tulip Fields, page 123
1984, Print: Serigraph, 16.5" x 27.5"
1985 Lamb Foundation Purchase Award

Erik Scott Nelson
Brattleboro, Vermont
b. 1953, Hartford, Connecticut
Windham Art Gallery, Brattleboro

Tree Farm, page 36
1993, Painting: Oil, 24" x 18"
1994 Land O'Lakes Purchase Award, Bonnie
 Neuenfeldt

Loren Nelson
Beaverton, Oregon
b. 1952, Colorado Springs, Colorado

Laurel Ridge Winery and Vineyard, page 154
1994, Photograph: Gelatin Silver Print, 15.5" x 19.5"
1995 Capital Press Purchase Award, Mike Forrester

Silos, Meeker Seed with Grain; Amity, OR, page 155
1998, Photograph: Gelatin Silver Print,
 19.5" x 15.5"
1999 Capital Press and Poster Award, Mike Forrester

Heidi Olsher
Formerly of Portland, Oregon
b. 1946, Los Angeles, California; d. 1988

Green Cows, page 37
1987, Painting: Oil on Canvas, 32" x 40"
1988 Paul Lamb and Reese Lamb Art About
 Agriculture Purchase Award, Lamb Foundation

Doris Frischknecht Opager
Formerly of Corvallis, Oregon
b. 1948, Tooele, Utah; d. 1987

Tradition in Flight I, page 201
1982, Sculpture: Wood, 24" x 16" x 6"
1983 Lamb Foundation Purchase Award

Alfred Owczarzak
Formerly of Corvallis, Oregon
b. 1923, The Bronx, New York; d. 2001

Untitled, page 156
1988, Photograph: Gelatin Silver Print, 9.5" x 4"
1989 ELANCO Purchase Award, Paul Berger

Muriel Pallay
Portland, Oregon
b. 1939, Carson, Washington

Oh Buttermilk Sky, page 74
1992, Watercolor, 22" x 30"
1993 Dean, Graduate School, Master of Arts
 Purchase Award, Tom and Carolyn Maresh

Todd Parker
Shelton, Washington
b. 1966, Erie, Pennsylvania

Twin Towers, page 157
2002, Photograph: Platinum-Palladium Print, 8″ x 10″
2003 Harrison Branch Juror's Award and Larry and
Sherry Kaseberg Purchase Award, OSU College
of Agricultural Sciences and Larry and Sherry
Kaseberg

Mary Anne Pauletto
Umpqua, Oregon
b. 1927, Escondido, California

Yesterday's Tools, page 75
Unlocated since 1998
1988, Watercolor, 22″ x 30″
1989 Carey and Glen S. Strome Agricultural Art
Memorial Purchase Award, Gayle Strome

Nancy Peterfreund
Seattle, Washington
b. 1950, New York City, New York
Lorinda Knight Gallery, Spokane, Washington

Swirled Tracks, page 158
2002, Photograph: Type C, 16″ x 20″
2003 Roy D. Nielsen Art About Agriculture Purchase
Award, the Roy D. Nielsen family

Cherry Boxes, page 159
2003, Photograph: Type C, 16″ x 20″
2004 Betty Brose Art About Agriculture and Cande
and Gene Buccola Purchase Awards; Betty Brose
and E. R. Jackman, and Cande and Gene Buccola

Connie Petty
Albany, Oregon
b. 1926, Los Angeles, California

Romanian Sheep, page 160
1990, Photograph: Type C, 8″ x 10″
1991 Dean, OSU College of Liberal Arts and Cande
and Gene Buccola Town and Country Realty
Purchase Awards; Bill Wilkins, and Cande and
Gene Buccola

Bob Pool
Salem, Oregon
b. 1937, Los Angeles, California

Jerseys, page 161
2000, Photograph: Type C, 16″ x 20″
2001 Bonnie Hall Juror's Purchase Award, OSU
College of Agricultural Sciences

Helix Wheatland, page 162
1991, Photograph: Type C, 16″ x 20″
1992 Director, Oregon Agricultural Experiment
Station Purchase Award, Missy and Thayne Dutson

Polk County Moonrise, page 163
1992, Photograph: Type C, 16″ x 23″
1993 Settecase Smith Doss, Architects Purchase
Award, Howard Smith

Daffodil Pasture, page 164
1998, Photograph: Type C, 16″ x 20″
1999 Extension Directors' Purchase Award, Lyla and
Michael Houglum and Peter and Mary Lou Bloome

Green Fields of Home, page 165
1998, Photograph: Type C, 16″ x 20″
1999 Cande and Gene Buccola Town and Country
Realty Purchase Award, Cande and Gene Buccola

Margaret Prentice
Eugene, Oregon
b. 1944, Indianapolis, Indiana

Water Makes Trees, page 124
2002, Print: Monoprint, Etching, and Hand Made
Paper, 22″ x 30″
2003 Betty Brose Art About Agriculture Award, Betty
Brose and E. R. Jackman

Robert S. Purser
Bellevue, Washington
b. 1940, Alexandria, Louisiana

Farming in 1986, page 193
1986, Mixed Media: Wood and Paper Construction,
34.5″ x 25.25″
1987 Paul Lamb and Reese Lamb Art About
Agriculture Purchase Award, Lamb Foundation

Sharon Rajnus
Malin, Oregon
b. 1940, Portland, Oregon
Rajnusart.com

The Ewes, page 76
1982, Watercolor, 15.5" x 28"
1983 Lamb Foundation Purchase Award

Marie "Lid" Rhynard
Wilsonville, Oregon
b. 1921, Moscow, Idaho

Sheepsheds at High Noon, page 77
1999, Watercolor, 13" x 10"
2000 Paul Lamb and Reese Lamb Art About
 Agriculture Purchase Award, Lamb Foundation

Carol Riley
Warrenton, Oregon
b. 1946, Portland, Oregon
www.carolriley.com

Vegetables, page 99
1983, Drawing: Oil pastel, 25.5" x 19.25"
1984 Lamb Foundation Purchase Award

Violets and Pears, page 125
1990, Print: Etching, 20" x 16"
1991 Capital Press Purchase Award, Dewey Rand

Richard Robertson
Formerly of Brownsville, Oregon
b. 1942, Eugene, Oregon; d. 2001

Higbee Farm, page 38
1985, Painting: Acrylic on rag paper,
 7.125" x 20.25"
1986 Lamb Foundation Purchase Award

John Rock
Formerly of Corvallis, Oregon
b. 1919, Tillamook, Oregon; d. 1993

Peoria Wheat Fields, page 39
1985, Painting: Oil on Canvas, 37.5" x 49.5"
1986 Lamb Foundation Purchase Award

Frances Ross
Eugene, Oregon
b. 1950, Brockport, New York

Hilltop View of Siena, page 78
1996, Watercolor, 16" x 21"
1997 Oregon Women for Agriculture Award

Marnie Ross
Corvallis, Oregon
b. Redcliffe, Alberta, Canada

Seed Sacks, page 79
1992, Watercolor, 18" x 24"
1993 Carey and Glen S. Strome Agricultural Art
 Memorial Purchase Award, Gayle Strome

Laura Ross-Paul
Portland, Oregon
b. 1950, Portland, Oregon
Courtesy Froelick Gallery, Portland

Find, page 51
2001, Watercolor, 22" x 15"
2002 Carey and Glen S. Strome Agricultural Art
 Memorial Purchase Award, Gayle Strome

Karen Rudd
Seattle, Washington
b. 1965, Madison, Wisconsin

Pea Pods, page 202
2004, Sculpture: Steel, 3.5" x 16.75" x 7.75"
2005 Roy D. Nielsen Art About Agriculture Purchase
 Award, Gwil Evans and William Cook

Victor Saltveit
Beaverton, Oregon
b. 1933, Portland, Oregon
The Village Gallery, Portland

Patterns, page 166
1993, Photograph: Type C, 8" x 10"
1994 Kaseberg Family Award, Larry and Sherry
Kaseberg

Judith Sander
Philomath, Oregon
b. 1949, San Diego, California
Corvallis Arts Center, Corvallis
Pegasus Gallery, Corvallis

Bovine Dinner Jacket for the Annual Feed and Dance,
page 177
1985, Fiber: Mixed Media, 13" x 17"
1986 Lamb Foundation Purchase Award

Clara Bell's Cow Chip Coat, page 178
1986, Fiber: Mixed Media, 9.5" x 13"
1987 Paul Lamb and Reese Lamb Art About
Agriculture Purchase Award, Lamb Foundation

*Zeke's Ceremonial Jacket for Chicken and Egg
Gathering,* page 179
1988, Fiber: Mixed Media, 12.5" x 25.5"
1989 Dean, College of Agricultural Sciences
Purchase Award, Jane and Roy Arnold

Erik Sandgren
Aberdeen, Washington
b. 1952, Corvallis, Oregon
Broderick Gallery, Portland
Karin Clarke Gallery, Eugene

A Pragmatic Poetry of Mist, page 80
2001, Watercolor, 22"x 30"
2002 Betty Brose Art About Agriculture Purchase
Award, Betty Brose and E. R. Jackman

Nelson Sandgren
Corvallis, Oregon
b. 1917, Dauphin Manitoba, Canada

The Gardener, page 126
Unlocated since 1998
1989, Print: Monoprint, 28" x 24"
1990 Dean, OSU College of Liberal Arts Purchase
Award, Bill Wilkins

Spring Series #3, page 40
1991, Painting: Oil on Board, 30" x 39"
1992 Monsanto Award, Darby Moeller

J. Elizabeth Santone
Carlton, Oregon
b. 1946, Coos Bay, Oregon
Portland Art Museum, Rental Sales Gallery

Farm Road, page 81
1991, Watercolor, 19" x 26"
1992 Capital Press Purchase Award, Dewey Rand

Jason Saunders
Corvallis, Oregon
b. 1967, New York, New York

Plow Bottom, page 203
1994, Sculpture: Ceramic and Photo,
12.5" x 18.5" x 4.5"
1995 Jurors' Recognition Purchase Award, OSU
College of Agricultural Sciences

Lauren Sauvage
Corvallis, Oregon

Peoria 8/10, page 127
1987, Print: Linoleum Cut, 18" x 24"
1988 Paul Lamb and Reese Lamb Art About
Agriculture Purchase Award, Lamb Foundation

Robert Schlegel
Banks, Oregon
b. 1947, Hillsboro, Oregon

Grain Elevator, page 42
2004, Painting: Acrylic on Panel, 18" x 14"
2005 Carey and Glen S. Strome Agricultural Art
Memorial Purchase Award, Gayle Strome

Susan Seubert
Portland, Oregon
b. 1970, Indianapolis, Indiana
Courtesy of Susan Seubert and Froelick Gallery,
Portland

Alliumphobia, page 167
2002, Photograph: Platinum Print, ed. 5, 6.75" x 6"
2003 Carey and Glen S. Strome Agricultural Art
Memorial Purchase Award, Gayle Strome

Douglas Campbell Smith
Bend, Oregon
b. 1939, Palo Alto, California
Portland Art Museum, Rental Sales Gallery, Portland

Bocca Marsh, page 41
1982, Painting: Oil on Canvas, 12" x 16"
1983 Lamb Foundation Purchase Award

Jennifer Smith
Bend, Oregon
b. 1946, England
Portland Art Museum, Rental Sales Gallery, Portland

Bob's Bunkhouse, page 128
1990, Print: Woodcut, 12" x 17"
1991 Settecase Smith Doss, Architects Purchase
Award, Howard Smith

Kim E. Smith

Edgefield Farm, page 82
1995, Watercolor, 20.5" x 28.5"
1996 Dean, Graduate School, Master of Arts
Purchase Award, Tom and Carolyn Maresh

Aki Sogabe
Bellevue, Washington
b. 1945, Japan
The Living Gallery, Ashland
Northwest Craft Gallery, Seattle, Washington

Homeward, page 194
1988, Mixed Media: Paper Cutting and Construction,
17" x 12.5"
1989 Oregon Women for Agriculture
Purchase Award

Cy Stadsvold
Corvallis, Oregon
b. 1932, Fergus Falls, Minnesota
Art in the Valley, Corvallis, Oregon

Wetlands Shadows, page 129
1990, Print: Monoprint, 11.5" x 12.5"
1991 OSU President's Purchase Award, John and
Shirley Byrne

Janice Staver
The Dalles, Oregon
b. 1939, Rochester, Minnesota
The Dalles Art Center, The Dalles
Columbia Art Gallery, Hood River, Oregon

Boys, My Money's All Gone, page 181
1989, Mixed Media: Collage, 25" x 27"
1990 Capital Press Purchase Award, Dewey Rand

Marly Stone

Duck Harvest, page 168
1994, Photograph: Gelatin Silver Print hand tinted
with oils, 20" x 16"
1995 Carey and Glen S. Strome Agricultural Art
Memorial Purchase Award, Gayle Strome

Susan Trueblood Stuart
Salem, Oregon
b. 1938, Moscow, Idaho

Tualatin Vineyard II, page 83
1993, Watercolor, 22" x 30"
1994 Dean, College of Agricultural Sciences
Purchase Award, Jane and Roy Arnold

Janet Sullivan
Missoula, Montana
b. 1951, Denver, Colorado

Primary Cut, page 87
1999, Drawing: Pastel, 10" x 7.25"
2000 Roy D. Nielsen Art About Agriculture Purchase
Award, the Roy D. Nielsen family

Gary Tepfer
Eugene, Oregon
b. 1951, Tucson, Arizona
White Lotus Gallery, Eugene

Wheat Field, Burgundy, page 169
1991, Photograph: Cibachrome Print, 15" x 15"
1992 Carey and Glen S. Strome Agricultural Art
Memorial Purchase Award, Gayle Strome

Donna B. Trent
Gig Harbor, Washington
b. 1938, Belfield, North Dakota
Earthworks Gallery, Lincoln City, Newport, Yachats
Campiche Studios, Long Beach, Washington
Lemon Tree, Tacoma, Washington
Harbor Gallery, Gig Harbor, Washington
Unique Art, Seattle, Washington

Ebey's Prairie Farm, Whidbey Island, page 43
1999, Painting: Oil Painting, 16.5" x 19.5"
2000 Capital Press Purchase Award, Mike Forrester

Winter Wheat Growing, page 44
1998, Painting: Oil on Canvas, 15" x 30"
1999 Carey and Glen S. Strome Agricultural Art
Memorial Purchase Award, Gayle Strome

Phyllis Trowbridge
Ashland, Oregon
b. 1965, Glen Cove, New York

Canal in March, page 45
1995, Painting: Oil on Paper, 6" x 9"
1996 Carey and Glen S. Strome Agricultural Art
Memorial Purchase Award, Gayle Strome

Charles True
Silverton, Oregon
b. 1948, Chicago, Illinois

Filbert Orchard at Sunrise, page 170–171
2000, Photograph: Digital Panorama, 3.75" x 38"
2001 Palisch Homes Purchase Award, Scott Houck

Yolanda Valdés-Rementeria
Chula Vista, California
b. 1949, Ensenada, Baja California, Mexico

Familias Campesinas, page 46
1994, Painting: Oil on Canvas, 61.5" x 41.5"
1995 Paul Lamb and Reese Lamb Art About
Agriculture Purchase Award, Lamb Foundation

Maurice A. Van
Eugene, Oregon
b. 1931, Kingston, Idaho
White Lotus Gallery

Strawscape, page 100
1990, Drawing: Ink, 30" x 22"
1991 The Original Oatmeal Baking Company and
Oregon Bread Purchase Award, Pat Shannon

Crows in a Winter Field, page 101
1992, Drawing: Ink, Watercolor, and Gouache,
22" x 28"
1993 Capital Press Purchase Award, Mike Forrester

Janna Beth Vaughn
Bonanza, Oregon
b. 1945

Turquoise Stove and Bread Rising Pan, page 130
Unlocated since 1998
1993, Print: Woodcut, 10" x 12.75"
1994 Settecase Smith Doss, Architects Purchase
Award, Howard Smith

Elise Wagner
Portland, Oregon
b. 1966, Jersey City, New Jersey
Butters Gallery, LTD, Portland

Dawn After Storm, page 47
1995, Painting: Encaustic and mixed media,
18" x 60"
1996 Paul Lamb and Reese Lamb Art About
Agriculture Purchase Award, Lamb Foundation

Harold R. Walkup
Beaverton, Oregon
b. 1942, Childress, Texas

Fall Farm, page 84
1984, Watercolor, 21" x 28.5"
1985 Lamb Foundation Purchase Award

April Waters
Salem, Oregon
b. 1954, Santa Monica, California
Mary Lou Zeek Gallery, Salem

Season's Edge, page 102
2000, Drawing: Pastel, 12" x 24"
2001 Cande and Gene Buccola Purchase Award,
Cande and Gene Buccola

Hank Weber
Vancouver, Washington
b. 1943, Brooklyn, New York
Artist's Gallery 21, Vancouver, Washington
Columbia Art Gallery, Hood River
The Dalles Art Association Gallery, The Dalles

Pear Trees and Hot Shadows, page 85
1992, Watercolor, 14.5" x 22"
1992 OSU President's Purchase Award, John and
Shirley Byrne

Robert Weller
North Plains, Oregon
b. 1936, East Orange, New Jersey
Lawrence Gallery, Sheridan, Oregon

In the Mill, page 48
1982, Painting: Acrylic, 24" x 30"
1983 Lamb Foundation Purchase Award

Diane Widler Wenzel
Albany, Oregon
b. 1943, Grass Valley, California
Pegasus Gallery, Corvallis

Mother Thinning Woodlot, page 49
1999, Painting: Acrylic on Canvas, 35.5" x 45.5"
2000 Paul Lamb and Reese Lamb Art About
Agriculture Purchase Award, Lamb Foundation

Old Boston Flour Mill, page 86
1994, Watercolor, 14" x 20"
1995 Kaseberg Family Purchase Award, Larry and
Sherry Kaseberg

Don Whitaker
Alsea, Oregon
b. 1938, Albany, Oregon

Forward to the Past, page 172
1994, Photograph: Gelatin Silver Print, 8" x 10"
1995 Vice Provost for Research and International
Programs Purchase Award, George and Suzanne
Keller

Lynn Wiley
Eugene, Oregon
b. 1940, Twin Falls, Idaho
Portland Art Museum Rental Sales Gallery, Portland
Print Arts Northwest, Portland

Homage to Passages, page 131
1997, Print: Relief Print, 12" x 12"
1998 Cande and Gene Buccola Town and Country
Reality Purchase Award, Cande and Gene Buccola

Carol Yates
Boston, Massachusetts

Wild Rose, page 132
1988, Print: Monoprint, 11.5" x 9.25 "
1989 OSU President's Purchase Award, John and
Shirley Byrne

Renée Zangara
Portland, Oregon
b. 1954, Oakland, California
Beppu/Wiarda Gallery, Portland

Blue Plate Special II, page 133
2002, Print: Monotype, 9" x 11.5"
2003 Dean and Director, College of Agricultural
Sciences and Oregon Agricultural Experiment
Station Purchase Award, Missy and Thayne Dutson

Mark Zentner
Eugene, Oregon

Patterns in Agriculture, page 50
1994, Painting: Acrylic and Collage, 24" x 28"
1995 Dean, OSU College of Liberal Arts Purchase
Award, Kay Schaffer

Sandra S. Zimmer
Tucson, Arizona
b. 1942, Kearney, Nebraska

Bowl of Spring, page 134
1990, Print: Serigraph, 12" x 18"
1991 ELANCO Purchase Award, Paul Berger

Bibliography

Lois Allan. *Contemporary Printmaking in the Northwest.* Sydney, Austrailia: Craftsman House, G+B Arts International, 1997.

Ginny Allen and Jody Klevit. *Oregon Painters: The First Hundred Years (1859–1959): Index and Biographical Dictionary.* Portland: Oregon Historical Society Press, 1999.

H. H. Arnason. *History of Modern Art.* Englewood Cliffs, NJ: Prentice-Hall, 1997.

Michael J. Balick and Paul Alan Cox. *Plants People and Culture: The Science of Ethnobotany.* New York: W.H. Freeman & Company, 1997.

Robert C. Baron, Editor. *The Garden and Farm Books of Thomas Jefferson.* Golden, CO: Fulcrum Inc., 1987.

Carol Buchanan. *Brother Crow, Sister Corn*: Traditional American Indian Gardening. Berkeley: Ten Speed Press, 1997.

Handasyde Buchanan. *Nature Into Art.* New York: Mayflower Books, 1979.

Michael J. Caduto and Joseph Buchac, with foreword by Marilou Awiakta. *Keepers of Life: Discovering Plants Through Native American Stories and Earth Activities for Children.* Golden, CO: Fulcrum Publishing, 1997.

Sally Cleveland. *Facing West/Other Portland Streets.* Portland, OR: Augen Gallery, 2006.

Rex Vicat Cole. *The Artistic Anatomy of Trees, Their Structure and Treatment in Painting.* Mineola, NY: Dover Publications, 1997.

Brian Dippie. *Charlie Russell: Paper Talk.* New York: Alfred A. Knopf, 1979. Published in association with the Amon Carter Museum of Western Art.

Douglas Dreishpoon. *Highlights from the Dillard Collection of Art on Paper: Drawn from Across the Century.* Greensborough, NC: Greensborough Printing, 1999.

Karrin Ellertson. "Art, Food and Fiber." *The Bear Deluxe: Exploring the Environment through the Creative Arts,* Number 19, Summer and Fall 2002: 10–11. Portland, Oregon.

Alan Feves. *Betty Feves.* Pendleton, OR: Mission Creek Press, 2000.

Terry Gips. *Narratives of African American Art and Identity: The David C. Driskell Collection.* San Francisco: Pomegranate Communications, 1998.

Randy Gragg. "Oregon's New Pantry," *The Oregonian,* April 20, 2002: C1, C3. Portland, Oregon.

Randy Gragg. "Reviving regionalism: art in a small corner," *The Oregonian,* November 25, 2001: E1, E4. Portland, Oregon.

Randy Gragg. "Sauvie Island Bridge needs image spanning its city and rural roots," *The Oregonian,* November 30, 2003: D1, D3. Portland, Oregon.

David Hagerbaumer and Sam Lehman. *Selected American Game Birds.* Caldwell, ID: Caxton Printers, Ltd., 1972.

Kitty Harmon. *The Pacific Northwest Landscape.* Seattle: Sasquatch Books, 2001.

Newton Harrison and Helen Meyer Harrison. *The Serpentine Lattice.* Portland, OR: Reed College Office of News and Publications, 1993.

Peter Hassrick. *Remington, Russell and the Language of Western Art.* Washington, DC: Trust for Museum Exhibitions, 2000.

Charles B. Heiser Jr. *Seed to Civilization: The Story of Food.* Cambridge, MA: Harvard University Press, 1990.

Hans Huth. *Nature and the American, Three Centuries of Changing Attitudes.* Berkeley: University of California Press, 1957.

H. W. Janson. *History of Art*. New York: Harry N. Abrams, 1969.

George Johanson. *Equivalents: Portraits of 80 Oregon Artists*. Portland, OR: Portland Art Museum, 2001.

Don Kirby. *Wheatcounty*. Tucson, AZ: Nazraeli Press, 2001.

Anna Klumpke, translated by Grete Van Slyke. *Rosa Bonher: The Artist's (Auto) Biography*. Ann Arbor: University of Michigan, 1997.

Leonardo da Vinci. New York: Reynal & Company, 1956.

"Leonardo da Vinci, Master Draftsman," an exhibition at the Metropolitan Museum of Art, New York, 2003.

Lucy R. Lippard. *The Lure of the Local: Senses of Place in a Multicentered Society*. New York: The New Press, 1997.

Metropolitan Arts Commission. *The Visual Chronicle of Portland, Volume One: Acquisitions 1985–1989*. Portland, OR: Metropolitan Arts Commission, 1990.

Cornelia F. Mutel and Mary Swander. *Land of the Fragile Giants: Landscapes, Environments, and Peoples of the Loess Hills*. Iowa City: University of Iowa Press, 1994.

National Gallery of Art. *Art for the Nation: Collecting for a New Century*. Washington, DC: National Gallery of Art, 2000.

Linda Nochlin. *Realism*. New York: Penguin Books, 1971 and 1983.

Georgia O'Keeffe. *Georgia O'Keeffe*. New York: Viking Press, 1976.

Christiana Payne (James C. Scott, Series Editor, Yale Agrarian Studies Series). *Toil and Plenty, Images of the Agricultural Landscape in England 1780–1890*. New Haven, CT: Yale University Press, 1994.

Maurice Raynal. *The History of Modern Painting from Picasso to Surrealism*. Geneva: Albert Skira, 1950.

Frederic G. Renner. *Charles M. Russell: Paintings, Drawings, and Sculpture in the Amon Carter Museum*. New York: Harry N. Abrams, 1974 (revised). Amon Carter Museum of Western Art (first published), 1966.

Joy Richardson. *Looking at Pictures: An Introduction to Art for Young People*. New York: Harry N. Abrams, 1997.

Laura Russo. *Manuel Izquierdo*. Portland, OR: The Laura Russo Gallery, 1992.

Mark Rozen. "Art About Agriculture," *The Capital Press,* February 27, 2004: 17. Salem, Oregon.

Lucia Tongiorgi Tomasi and Gretchen Hirschauer. *The Flowering of Florence: Botanical Art for the Medici*. Washington, DC: National Gallery of Art, 2002.

Emily Toth. *Regionalism and the Female Imagination: A Collection of Essays*. New York: Human Sciences Press, 1985.

Robert Sayre. *Recovering the Prairie*. Madison: The University of Wisconsin Press, 1999.

Muriel Silberstein-Storfer and Mablen Jones. *Doing Art Together*. New York: Harry N. Abrams, 1996.

Stewart L. Udall. *The Quiet Crisis*. New York: Holt, Rinehart and Winston, 1963.

Herman J. Viola. *Seeds of Change: A Quincentennial Commemoration*. Washington DC: Smithsonian Institution Press, 1991.

Jana Zvibleman. "Art About Agriculture," *Oregon's Agricultural Progress*, Summer 2005: 14–15. Corvallis, OR: Oregon Agricultural Experiment Station, Oregon State University.

Contributors

Lois Allan is the author of *Contemporary Printmaking in the Northwest* (Craftsman House, 1997) and *Contemporary Art in the Northwest* (Craftman House, 1995). She contributed to *Modernism and Beyond: Women Artists of the Pacific Northwest* (Midmarch Arts Press, 1993) and has published criticism, features, and essays for magazines and art exhibition catalogs for two decades. She was one of five organizers of the 2001 international print conference, "Crossing Boundaries: East-West Symposium on Print Art" in Portland, Oregon. She has co-curated several art exhibitions in Oregon and Washington and serves on the Public Art Advisory Committee for the Regional Arts and Culture Council and as an advisor to the board for the Friends of the Gilkey Print Center at the Portland Art Museum.

Shelley Curtis, Editor, is directing curator of Art About Agriculture in the Oregon State University College of Agricultural Sciences. She has more than twenty years of professional experience in art education, art exhibition, and art production. She has responsibility for public presentations of Art About Agriculture tour exhibits and permanent collection displays. As directing curator, she administers a program that recognizes innovations and investigations by contemporary Pacific Northwest artists and rests upon traditions of building community among diverse rural and urban audiences. She holds master of fine arts and master of arts degrees in photography and sculpture from the University of Iowa and a bachelor of fine arts from Oregon State University.

Gwil Evans is one of the founders of the Art About Agriculture program. He is emeritus professor of communication at Oregon State University. He has served in a variety of roles, including journalism teacher, first communications director for the Sea Grant College program, editor of the *Oregon Stater* alumni magazine, director of University Publications, director of the Oregon State University Press, director of Extension Communications, and department head for Agricultural Communications. He is executive producer of Oregon Invests!, one of the nation's first research and education accountability systems. For the past decade, he has served as a senior administrator in the OSU College of Agricultural Sciences.

Index

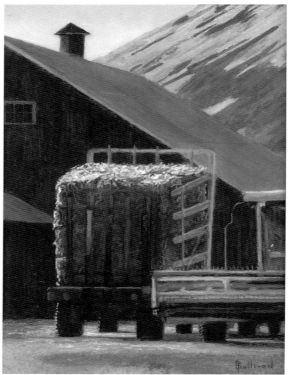

Primary Cut by Janet Sullivan

Colophon

Titles are set in Bodoni, a classical typeface designed by Giambattista Bodoni of Parma, Italy, in the late eighteenth century. Text is set in Univers Light, a sans serif font designed by Adrian Frutiger in 1956. Initial capitals are set in Snell Roundhand, a script font developed in 1965 by Matthew Carter and based on the original Snell, circa 1694.